FEDERICO ZERI (Rome, 1921-1998), eminent art historian and critic, was vice-president of the National Council for Cultural and Environmental Treasures from 1993. Member of the Académie des Beaux-Arts in Paris, he was decorated with the Legion of Honor by the French government. Author of numerous artistic and literary publications; among the most well-known: *Pittura e controriforma*, the Catalogue of Italian Painters in the Metropolitan Museum of New York and the Walters Gallery of Baltimora, and the book *Confesso che ho sbagliato*.

Work edited by FEDERICO ZERI

Text
based on the interviews between
FEDERICO ZERI and MARCO DOLCETTA

This edition is published for North America in 2000 by NDE Publishing*

Chief Editor of 2000 English Language Edition
ELENA MAZOUR (*NDE Publishing**)

English Translation
SUSAN SCOTT

Realization
ULTREYA, MILAN

Editing
LAURA CHIARA COLOMBO, ULTREYA, MILAN

Desktop Publishing
ELISA GHIOTTO

ISBN 1-55321-016-6

Illustration references

Alinari Archives: 4a-b, 16-17, 18, 412a, 44/I, 45/VIII.

Alinari/Giraudon Archives: 1, 2s, 3, 6d, 8, 9, 10s-d, 11s-d, 12s-d, 13s-d, 15a-b, 19, 21, 27, 31, 38, 41d, 44/II-IX, 45/I-III-VII.

Giraudon/Alinari Archives: 37, 44/V.

Luisa Ricciarini Agency: 6s, 14, 24, 28, 29, 34, 40b, 41s, 42b, 44/IV-X, 45/IV.

RCS Libri Archives: 7, 20a, 23, 25, 26, 30, 33, 39, 42b, 43, 44/III-VI-VII-XI-XII, 45/II-V.

R.D.: 2d, 5, 16, 20b, 22, 32, 35, 36, 40a, 44/VIII, 45/VI-IX-X-XI-XII-XIII-XIV

Printed and bound by Poligrafici Calderara S.p.A., Bologna, Italy

a registered business style of NDE Canada Corp.
15-30 Wertheim Court, Richmond Hill, Ontario
L4B 1B9 Canada, tel. (905) 731-1288

The captions of the paintings contained in this volume include, beyond just the title of the work, the dating and location. In the cases where this data is missing, we are dealing with works of uncertain dating, or whose current whereabouts are not known. The titles of the works of the artist to whom this volume is dedicated are in blue and those of other artists are in red.

PONTORMO
DEPOSITION

The DEPOSITION, the altarpiece adorning the Capponi chapel in the Florentine church of Santa Felicita, is the supreme cry of Pontormo, the Mannerist painter who more than any other infused his own inner

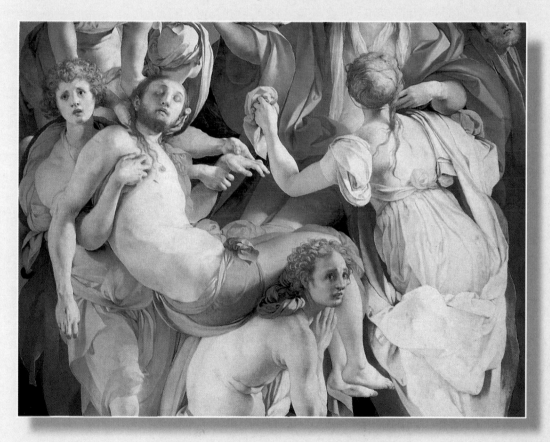

torment into his work. Breaking with figurative tradition, in the DEPOSITION the artist articulates an anticlassical language, setting the figures in a visionary space, practically abolishing chiaroscuro, and placing cool, acid colors alongside each other in unconventional and sometimes jarring combinations.

"HIS BRAIN WAS ALWAYS INVESTIGATING"

◆ JACOPO CARUCCI DA PONTORMO
The Tuscan painter (1494-1557) was known for his taciturn, misanthropic nature. Only painting could pull him out of his loneliness, becoming for him a moment of spiritual growth even more than artistic expression. By putting his self-portrait in the Capponi chapel altarpiece, he intended to bear witness to the intensity of his faith.

DEPOSITION
1526-28

● Florence, Capponi chapel, Santa Felicita (oil on wood, 313x192cm)

● In his *Lives*, Giorgio Vasari reconstructs anecdotally, but with keen insight, the unique, troubled personality of Jacopo Carucci, called Pontormo after his native town near Empoli. Vasari reports how the artist would tormentedly meditate and remeditate before putting hand to brush and how, dissatisfied, he would erase his work and start all over again.

● Solitary, melancholy, and misogynous by nature, Pontormo took his position in the Florentine panorama as a different voice, out of the mainstream. His personal reworking of the inspiration received from his teachers led him to develop an anticlassical style, which was strongly subversive in terms of Renaissance figurative tradition and was not immune from expressionistic tendencies absorbed from northern European art. His was a style that critics, often disparagingly, have called *Mannerism*.

● His work has to be viewed in its contemporary historical and artistic context. The year of his birth, 1494, was the year of the expulsion of the Medici from Florence, and in the course of his life the painter witnessed their alternating triumphs and defeats. Between reconquests of power and grievous exiles, the Medici became his principal patrons.

● Exceptional masters – Leonardo, Piero di Cosimo, Mariotto Albertinelli, and Andrea del Sarto – contributed to forge his style, often with contrasting suggestions. From Leonardo, between 1506 and 1508, Pontormo learned the use of chiaroscuro and the modulation of light. Piero di Cosimo seduced him with his unreal atmosphere and his adherence to the ideas of Savonarola, which he shared with Albertinelli. But Andrea del Sarto was the painter's true teacher, and Pontormo worked in his shop between 1512 and 1513.

● Above everyone, however, towered Michelangelo, an admirer and friend of Pontormo, who with his heroically sculptural figures and his aesthetic experience painfully merging art and life, became the younger painter's main point of reference.

● Along with Andrea del Sarto and his friend Rosso Fiorentino, Pontormo inaugurated the season of Mannerism, which he would then develop with his student Bronzino. In the *Deposition*, the work that has become the manifesto of this style, he unites technical virtuosity with a creative force whose emotional impact is compelling.

◆ A DIARY WRITTEN AS A CHRONICLE
In the last years of his life, from 1554 to 1557, Pontormo felt the need to note every event in his days on the pages of a diary that remains as a valuable document, especially considering the fact that the artist's last works have been lost. It is surprising that the painter did not express his moods or states of mind, but rather recorded marginal information like what he ate, meetings with friends, the weather, how his work was getting on, accompanying these notations with sketches of figures. The image that emerges is a gloomy one of an austere life of poverty.

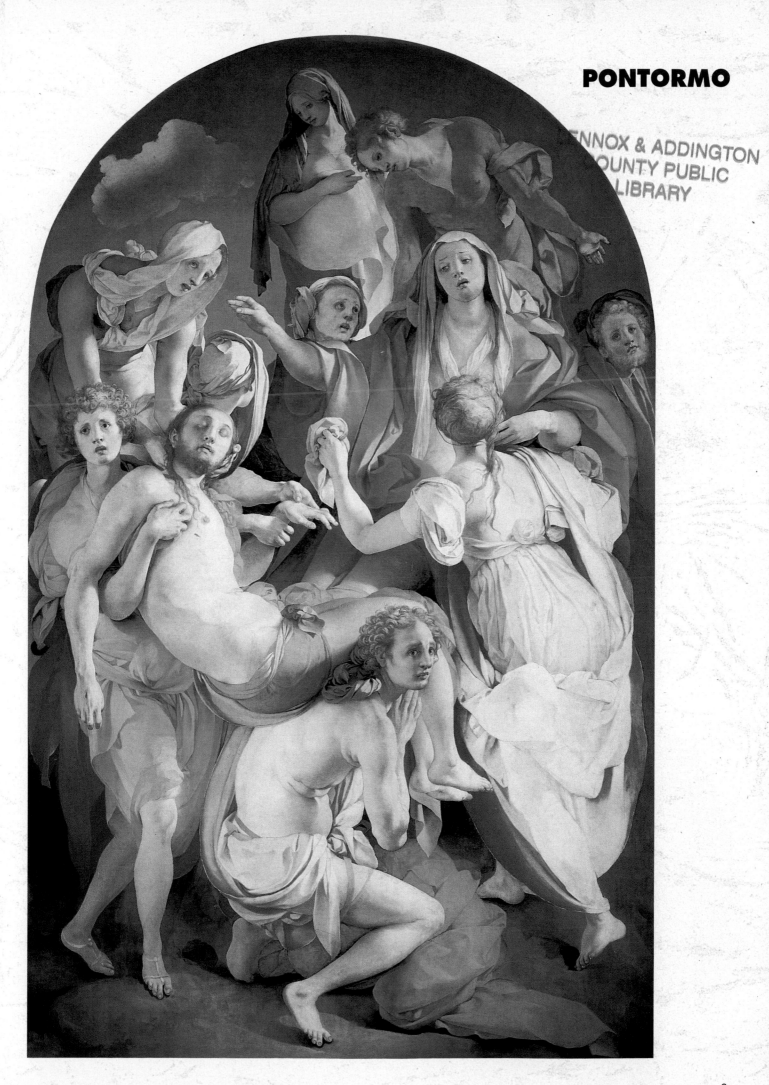

THE CAPPONI CHAPEL

The Church of Santa Felicita rises near the banks of the Arno and not far from Palazzo Pitti, on land that was already inhabited by early Christian times. The single-nave interior is enriched with side chapels; outstanding among them is the first on the right, built between 1420 and 1423 by Brunelleschi.

● The chapel originally belonged to Bartolomeo Barbadori, but was purchased in 1525 by Ludovico Capponi, a Florentine banker who had returned to his city from Rome in 1521 and become a member of the Republican government. It was he who commissioned Pontormo to provide the new decoration of the walls.

● The chapel underwent various alterations over time which substantially changed its aspect. After 1620 Orazio Capponi added to the entrance wall a reliquary monument to Saint Charles Borromeo, and in 1722 Ferrante Capponi had the altarpiece restored, an operation which was later seen to have been too drastic.

● It was, however, the unfortunate renovations carried out in 1766 which altered the original decorative and architectural aspects of the space. The vault of Brunelleschi's dome was low-

♦ ST LUKE (c. 1526, Florence, Capponi chapel). St Luke is the only one of the four *Evangelists* captured in the act of writing. With his head turned upwards, he seems to emphasize the divine nature of his inspiration. His figure is striking for the chromatic force of his clothing, accentuated by the white light.

ered, destroying the image of God the Father which Pontormo had placed there at the height of the symbolic crescendo of his figurative work.

● The chapel was initially consecrated to the Annunciation, but Ludovico Capponi rededicated it to the Deposition and destined it to hold family tombs, for which Pontormo's decoration was well suited. Besides the altarpiece and the vault with the image of God, the artist frescoed the right wall with an *Annunciation* and painted the four *Evangelists* in the pendentives in collaboration with Bronzino, who is responsible for Saint Mark and perhaps also Saint Matthew, according to Vasari's *Lives*.

♦ ST JOHN THE EVANGELIST (c. 1525, Florence, Capponi chapel). The figure of Saint John is imposing in the realism of the line and the contrast between the raking light which defines the body and the black background. The softness of his beard counterposes the rigidness of the drapery.

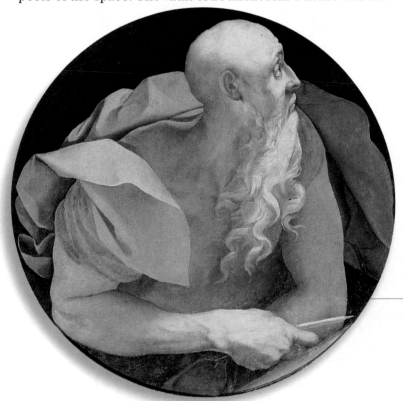

Death, the subject of the altarpiece, becomes in reality man's return, saved by Christ's sacrifice, to God who awaits him on high in the vault.

● Complementing the cycle, Guglielmo da Marcillat made in 1526 a stained glass window representing *The Deposition* and *The Entombment*, transferred in the eighteenth century to Palazzo Capponi.

♦ ANNUNCIATION (c. 1527-28, Florence, Capponi chapel). On the west wall of the chapel Pontormo placed the scene which initiates the earthly existence of Christ and thus the redemption of humankind: the Annunciation to the Virgin. While the other works in the chapel are in oil on wood panel, this is the only fresco. In the angel, Pontormo prefigures a Baroque handling of the draperies, while the Virgin Mary echoes models by Botticelli.

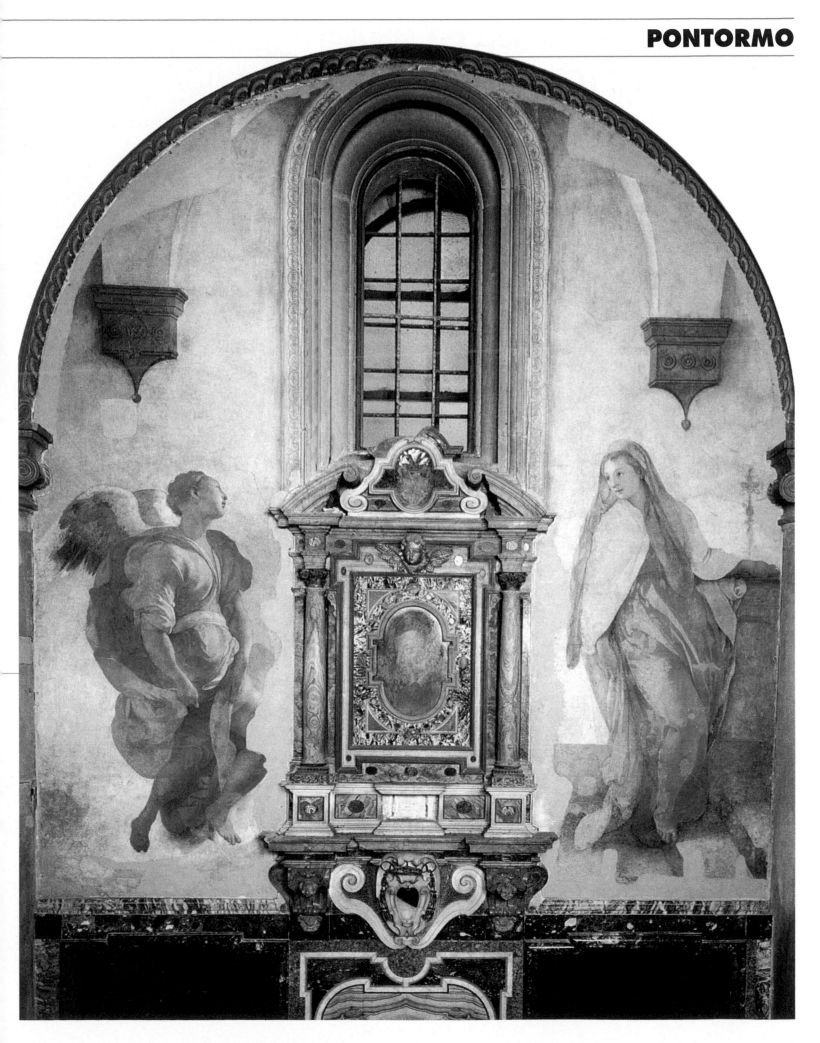

AN AMBIGUOUS THEME

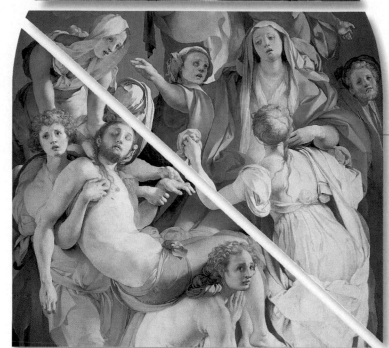

The iconography of the altarpiece is not easy to decipher. Sources have told us it is a *Deposition*, but in reality there is no cross, an indispensable element for representation of that scene. As Vasari also notes, the painting seems to be more a *Transport of Christ to the Tomb*. However, the stained glass window by Guglielmo da Marcillat, which was already installed in the chapel, represented precisely the two moments of the *Deposition* and the *Transport*. The subject of the

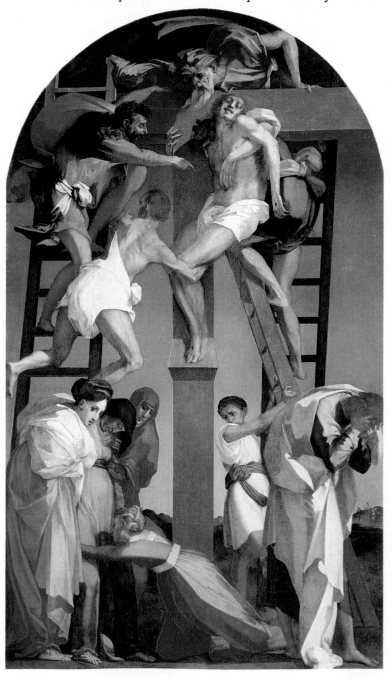

altarpiece would thus be redundant. The crucial role attributed to the Virgin and her Son indicates that the thematic core of the action is in actuality the moment of their separation.

● It is not possible to define with certainty the directions of the group's movements. And yet, the void created in the center of the scene evokes separation, like a disjointed *Pietà*. The power of the altarpiece, above and beyond the virtuosity of its execution, thus resides also in its iconographical innovation.

● This interpretation is supported by the overall iconography of the chapel and its funerary destination: the dead Christ is awaited by the Father above, at the highest point of the chapel, as a manifestation of the possibility for salvation granted to man by his sacrifice.

● In this unprecedented *Pietà*, in which Christ seems to be sliding towards the altar, recent criticism has also seen the theme of the Adoration of the Eucharist, a frequently recurring motif in the devotions of the Theatine Fathers, an order founded in Rome in 1524 which Pontormo had discovered through his friend Michelangelo, who gravitated in the circle of the congregation.

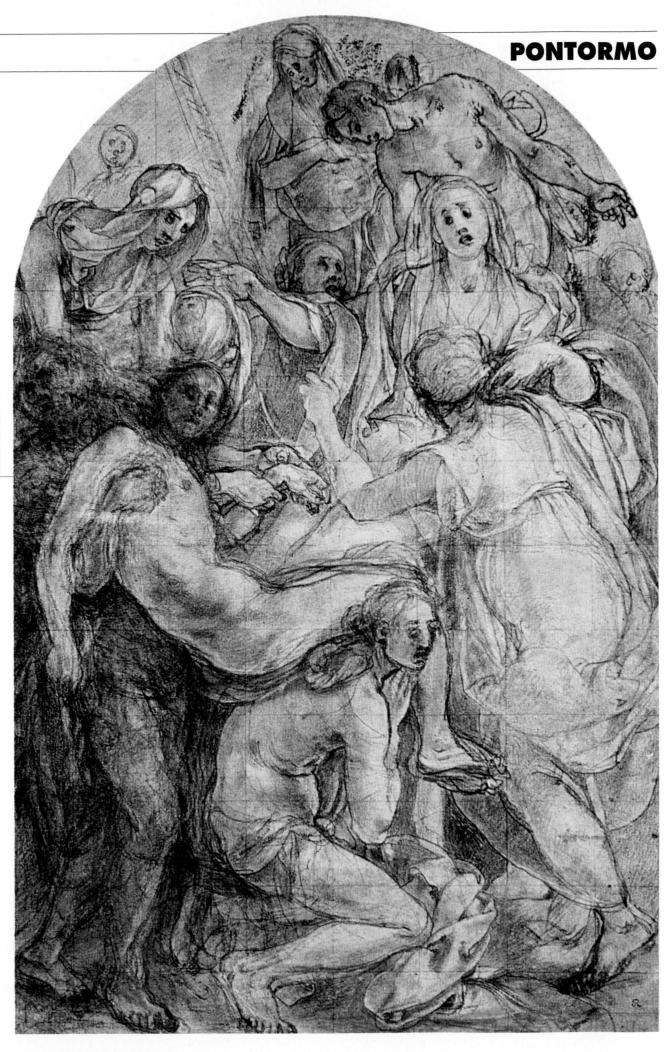

◆ **THE LAST FAREWELL**
With almost metallic colors and a white light which sheds a cool tone over the figures, the Virgin bids Christ her last farewell. His leaden-colored body is borne toward the left, while his Mother is held back and supported by the handmaidens. The opposite direction of their movements is underlined by the poses of the other figures.

◆ **THE PREPARATORY DRAWING**
In his original concept, Pontormo had proposed a more traditional iconographical scheme, which with the cross in the background could be recognized without hesitation as a *Deposition*. In the final version he replaces the cross with a cloud, and with this apparently marginal variation invests the scene with symbolic resonance.

◆ **ROSSO FIORENTINO**
Deposition
(1521, Volterra, Pinacoteca Civica)
The altarpiece painted by Rosso Fiorentino, whom Pontormo had known in Andrea del Sarto's workshop, represents the theme of the *Deposition* with a composition that is dynamic in its spatial relationships, but rigid in its forms. Violent colors, stiff draperies, and expressionistic details like the old man looking over the cross, impart an agitated air to the scene, which compared to Pontormo's altarpiece is thus more narrative in nature.

A GRIEF NARRATED IN SILENCE

Pontormo gives the scene its emotional force by narrowing his focus solely to the group of figures, without yielding any space to a setting. Like a cluster of intertwining forms, the figures disentangle themselves from each other in a rhythm similar to a dance. Light, yet tormented at the same time, they move the composition towards the top and then back towards the bottom, rendering with their dynamism the impression of an event in progress, a drama that is still taking place: a drama witnessed by the painter, as he himself underlines by placing himself among the participants.

● Pontormo abstains from a description of the New Testament story; he leaves out details like the ladder and the cross on the hill of Golgotha and reduces the setting in space to the dark earth at the bottom of the picture. He does not render identifiable the facial features of the bystanders but makes the various faces alike to the point that they seem almost like angels in their unreal resemblance to each other, unifying them also in the colors of their clothing. Then, changing the traditional cast of characters usually present in *Depositions*, he inserts two beardless youths and increases the number of the pious women.

● Three-dimensionality is achieved not with Renaissance perspective but by the accentuated volume of the bodies and by the play of their poses, which create the space with movements that are alternatingly symmetrical and opposed. The choral representation, heightened by the lively dialogue of the hands, is, however, everywhere kept subdued, restrained. The faces are grief-stricken, but their expressions are not theatrical. The gestures are communicative yet spontaneous. Everything works together to render the intensity of the moment, while the sense of suffering is amplified by the controlled demeanor of the bystanders.

● Every movement reveals a precise state of mind: the grieving Mother's farewell to her Son, the young woman's prompt aid to the swooning Virgin, the desperation now repressed, now resigned of the pious women. The two men display the body of Christ as though to emphasize the cost of redemption.

● Pain emanates from the staring eyes, the half-closed lips, the excited gestures, the gaze out of the picture as though to pull the spectator into the drama. And yet the body of Christ, cleansed of every trace of blood, his face serene, does not evoke the Passion, but links the idea of death with the promise of resurrection for mankind.

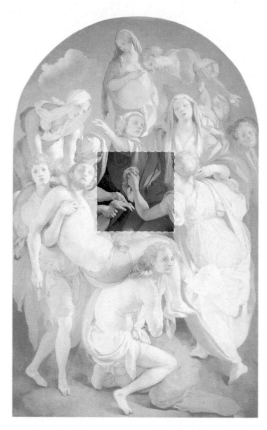

◆ THE DIALOGUE OF THE HANDS
The symbolic fulcrum of the composition is the center, where in the conjunction of their hands the separation of the Mother from her Son becomes real, and the direction lines of the movement of the scene all come together. The figures are arranged in a circle and seem to turn around a pivot in space occupied only by the arms. Christ's inert arm is held up by a half-hidden figure, whose veiled head is all that can be seen. The one holding out a cloth to the Virgin is instead charged with an ascendent thrust and seems to balance the lifelessness of the nearby arm of Christ. Pontormo renders the anatomy of the hands with a sharp contour line, tracing the shadows with short brown brushstrokes. With expressive realism, he entrusts to the various poses an emotional meaning capable of substituting for words.

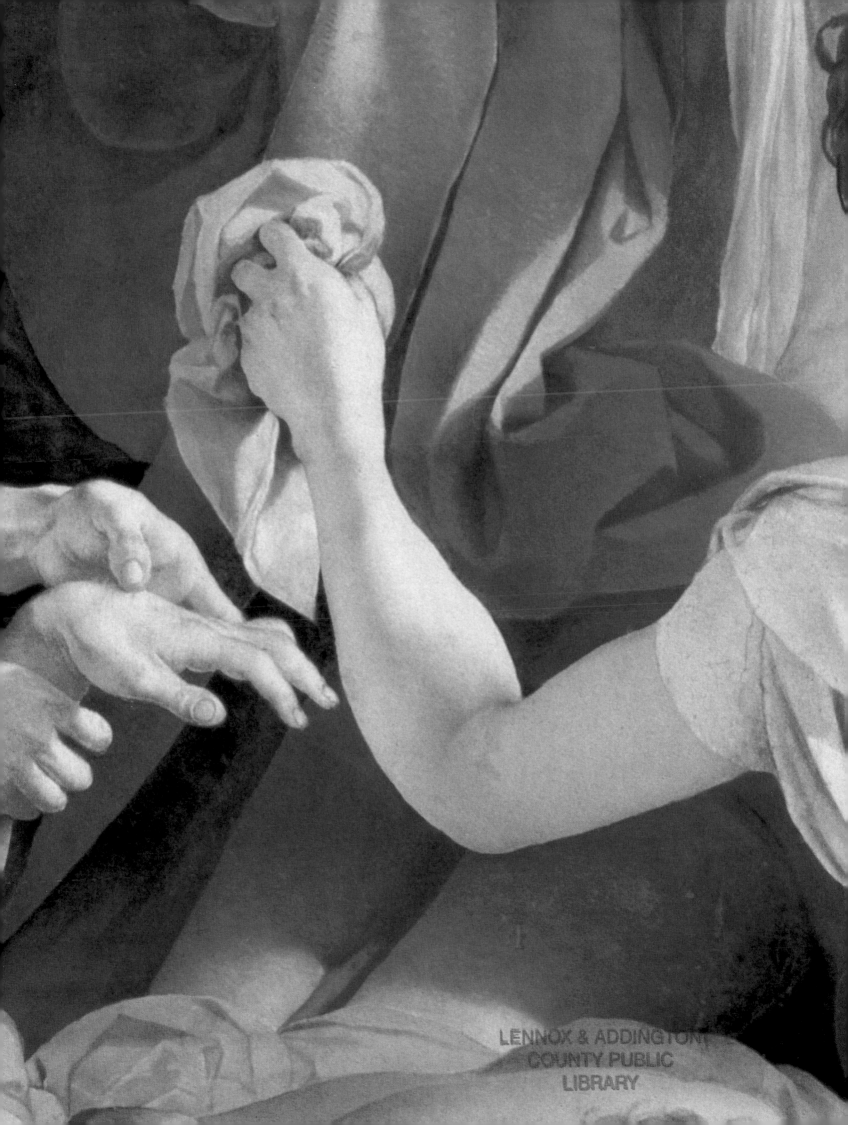

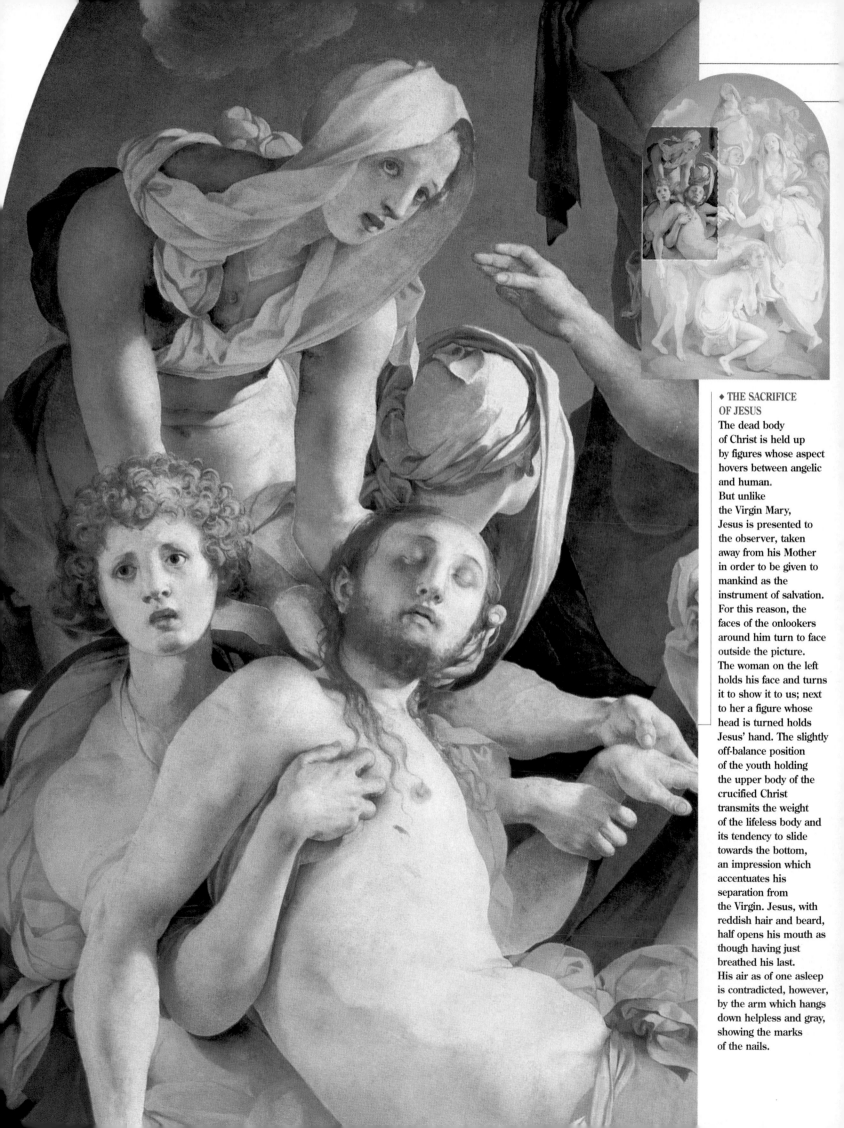

◆ THE SACRIFICE
OF JESUS
The dead body
of Christ is held up
by figures whose aspect
hovers between angelic
and human.
But unlike
the Virgin Mary,
Jesus is presented to
the observer, taken
away from his Mother
in order to be given to
mankind as the
instrument of salvation.
For this reason, the
faces of the onlookers
around him turn to face
outside the picture.
The woman on the left
holds his face and turns
it to show it to us; next
to her a figure whose
head is turned holds
Jesus' hand. The slightly
off-balance position
of the youth holding
the upper body of the
crucified Christ
transmits the weight
of the lifeless body and
its tendency to slide
towards the bottom,
an impression which
accentuates his
separation from
the Virgin. Jesus, with
reddish hair and beard,
half opens his mouth as
though having just
breathed his last.
His air as of one asleep
is contradicted, however,
by the arm which hangs
down helpless and gray,
showing the marks
of the nails.

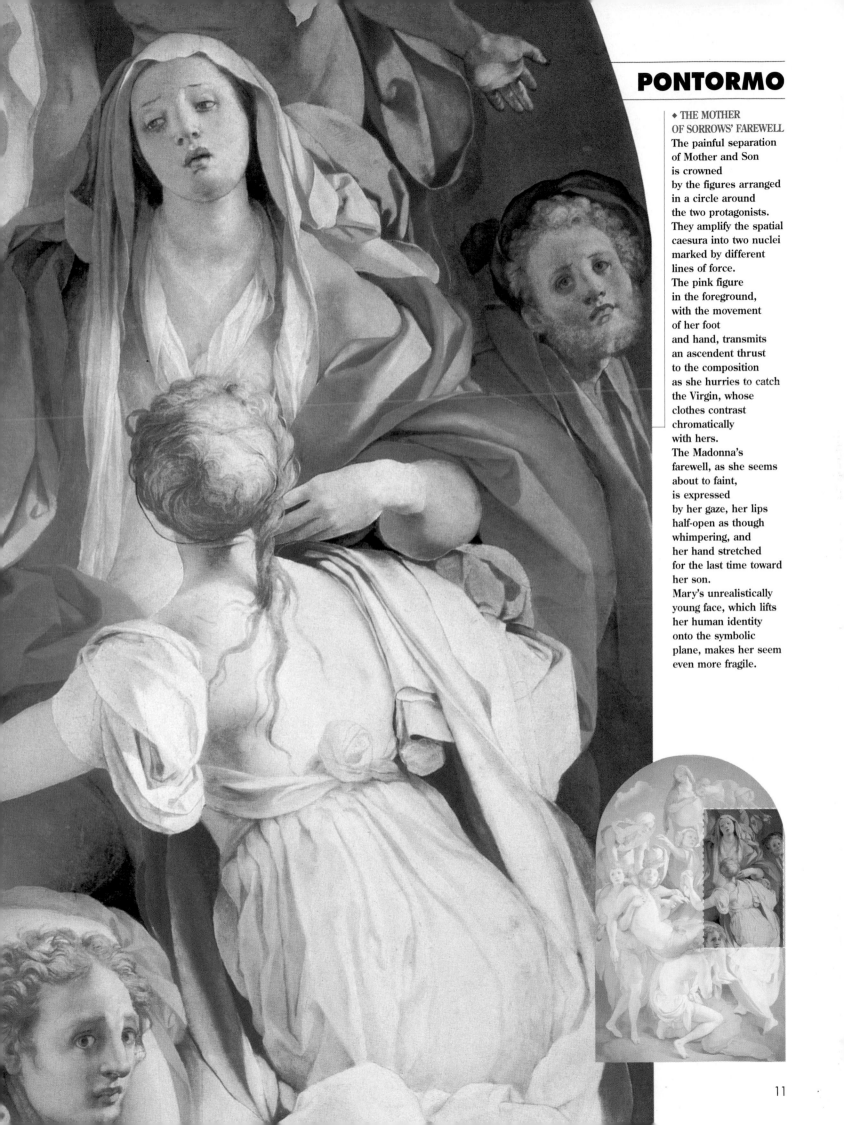

PONTORMO

◆ THE MOTHER
OF SORROWS' FAREWELL
The painful separation
of Mother and Son
is crowned
by the figures arranged
in a circle around
the two protagonists.
They amplify the spatial
caesura into two nuclei
marked by different
lines of force.
The pink figure
in the foreground,
with the movement
of her foot
and hand, transmits
an ascendent thrust
to the composition
as she hurries to catch
the Virgin, whose
clothes contrast
chromatically
with hers.
The Madonna's
farewell, as she seems
about to faint,
is expressed
by her gaze, her lips
half-open as though
whimpering, and
her hand stretched
for the last time toward
her son.
Mary's unrealistically
young face, which lifts
her human identity
onto the symbolic
plane, makes her seem
even more fragile.

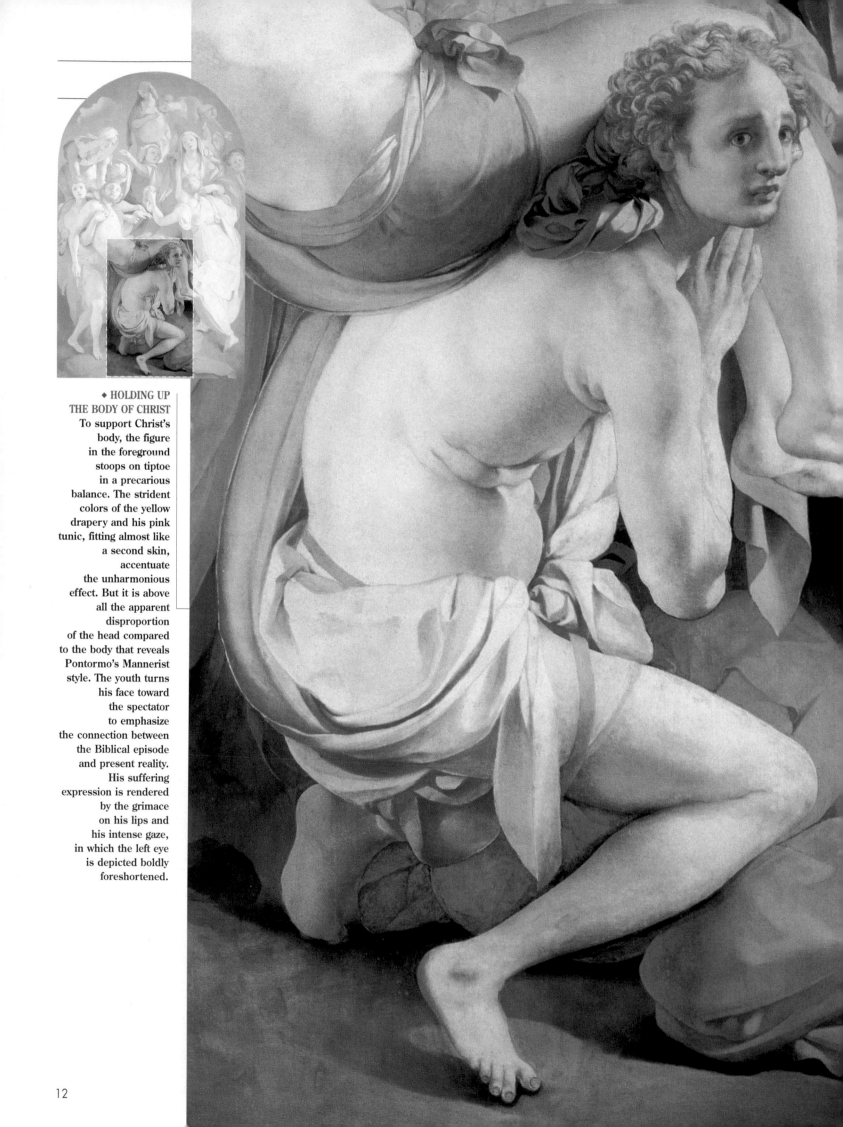

◆ HOLDING UP
THE BODY OF CHRIST
To support Christ's
body, the figure
in the foreground
stoops on tiptoe
in a precarious
balance. The strident
colors of the yellow
drapery and his pink
tunic, fitting almost like
a second skin,
accentuate
the unharmonious
effect. But it is above
all the apparent
disproportion
of the head compared
to the body that reveals
Pontormo's Mannerist
style. The youth turns
his face toward
the spectator
to emphasize
the connection between
the Biblical episode
and present reality.
His suffering
expression is rendered
by the grimace
on his lips and
his intense gaze,
in which the left eye
is depicted boldly
foreshortened.

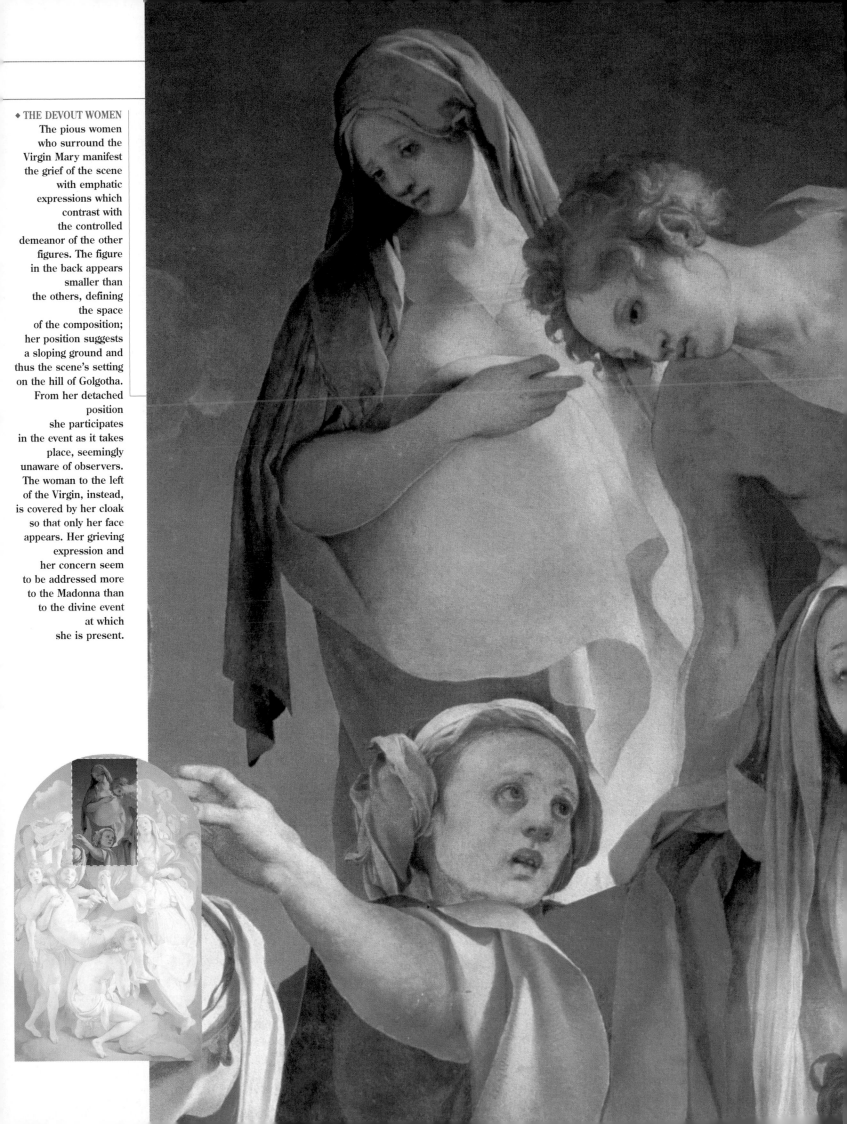

◆ THE DEVOUT WOMEN
The pious women
who surround the
Virgin Mary manifest
the grief of the scene
with emphatic
expressions which
contrast with
the controlled
demeanor of the other
figures. The figure
in the back appears
smaller than
the others, defining
the space
of the composition;
her position suggests
a sloping ground and
thus the scene's setting
on the hill of Golgotha.
From her detached
position
she participates
in the event as it takes
place, seemingly
unaware of observers.
The woman to the left
of the Virgin, instead,
is covered by her cloak
so that only her face
appears. Her grieving
expression and
her concern seem
to be addressed more
to the Madonna than
to the divine event
at which
she is present.

A GLACIAL PALETTE

Almost like a stylistic manifesto, the altarpiece reveals a unique artistic concept which leaves behind classicism both in compositional structure and palette. Pontormo's bodies move in a spiralling motion marked by tormented rhythms. The forms that emerge from the sharply defined, calligraphic contour lines, typical of the Florentine tradition, possess an almost metallic hardness. The colors are cold, made even more unnatural by the white light and the jarring color combinations.

● As Vasari reports, the artist worked in complete, voluntary solitude, "Having erected an enclosure,

● MICHELANGELO
The Doni Tondo
(1504-06,
Florence, Uffizi)
The unnatural,
metallic palette
and hard draperies
adopted in the Santa
Felicita altarpiece have
a precedent in the birth
salver painted
by Michelangelo,
with which Pontormo
was familiar.
The torsion of the
Virgin's body,
a pose used habitually
by Michelangelo, also
recurs in Pontormo's
work, emphasizing with
its broken rhythm
the absence of any
harmonious elements.

which kept that chapel closed for three years, he set his hand to the work." And yet his style betrays the effect of numerous influences: the dynamic serpentine movement of the figures is the result of his attention to the heroic torsions imposed by Michelangelo; the sharply defined lines constructing the volumes reveal a knowledge of the analytical engravings of Albrecht Dürer.

● Thus the Santa Felicita altarpiece offers evidence of the fact that he had by now gone beyond the unquestionable models of Raphael, Leonardo, and Michelangelo. His reworking of their lessons in the direction of unstable forms and harsh, shrill colors is described with the pejorative term *Mannerism*, indicating a sterile imitation of the manner of the three Renaissance mas-

ters. But in Pontormo this overturning of their styles gives him a foundation on which to build his own autonomous expressive language, based on serpentine lines, contrasting colors, contradicting proportions, and unsteady perspective. It is a style which, rather than satisfying the spectator, transmits to him the same sense of existential and historical uncertainty as the painter himself felt.

● Looked at more closely, then, Pontormo's restless sensibility, a reflection of the changing political and religious climate, and his eagerness to experiment led him in the direction of a language in continual

◆ A PLAY OF COLOR
The figures in the
Deposition are portrayed
using two dominant
tones: pink and blue.
While the pink
draperies move
the image toward
the surface, the blue
ones immerse it into
the depths, yielding an
optical effect which
Pontormo utilizes
to give depth of space
to the painting.
His recourse to an acid
green for the transparent
cloth wrapped around
Christ and the clothing
of the figure at the top
is so disquieting as
to introduce a spectral
note into the scene.

evolution and one marked constantly by innovation. His painting restores to the figures the features of a tormented inner life, an original pathos, well beyond the measured, controlled emotional climate of the classicist canon.

● But beyond its iconographical innovations and its formal variety, the altarpiece is striking for its recourse to cold, strident, unnatural colors. Long thought to be the consequence of harsh restoration in 1722, in reality the colors derive from Michelangelo and in particular from his *Doni Tondo*, whose brilliant tonality it shares, but also its abrupt passage between light and shade, a stylistic choice which Vasari remarks with surprise and disapproval.

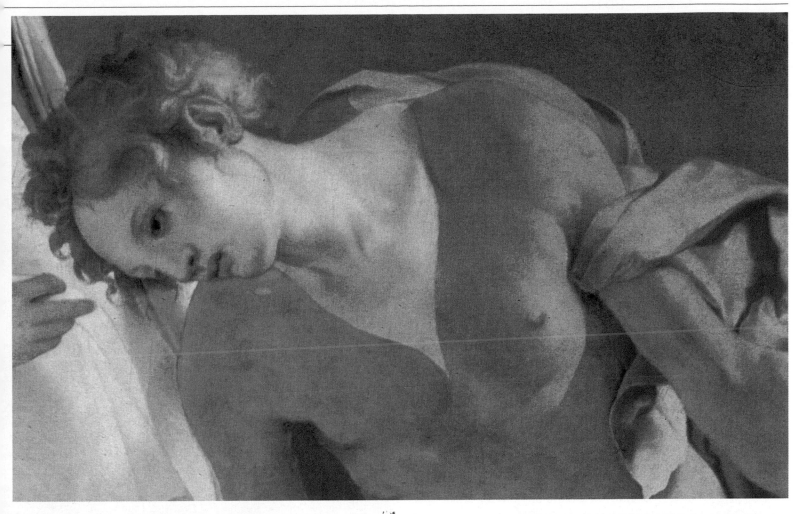

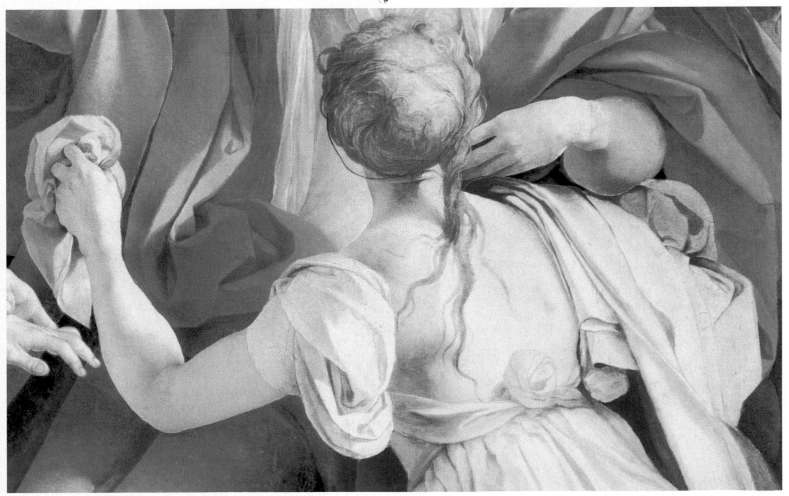

THE BUSINESS OF LIVING

Aflorid literature has handed down to us the picture of a saturnine Pontormo, underlining his misanthropy, hypochondria, and especially his jealously guarded solitude, interrupted only by a few friends. But it is the artist himself who confirms to this image in his *Diary*, written between 1554 and 1556 while he was working on the decorations for the church of San Lorenzo.

● Unlike his artistic contemporaries like Benvenuto Cellini, who conceived of the diary as a literary and popular form, Pontormo eschewed any stylistic or existential considerations and any attention to vocabulary. His pages constitute a chronicle in which banal repetitions follow each other with an almost obsessive rhythm that reveals anxiety and insecurity.

● The painter noted whether and what he ate, if he met his friends – especially Bronzino – or if someone did not show up at the appointed time. He recorded obsessively the weather and the state of his health. At the same time, he marked the progress of his work and indicated what figures he had painted, often accompanying this with a sketch in the margin.

● Above and beyond questions of temperament, the events of his life, too, contributed to making him even more fragile. Born in Pontorme, near Empoli, in 1494, the painter was an orphan by the age of ten. Raised by his grandmother, after 1508 he was entrusted to the Florentine magistrates in charge of the care of orphans. In 1517 he lost his sister and found himself alone in the world.

● During the course of his life, spent almost uninterruptedly in Florence, Pontormo appears to have been well inserted into the changing social and political context of the city, but he did not break his isolation and always kept his distance from those in power. Tradition says he was a republican, yet the abundance of commissions received from the Medici family gives evidence to the contrary. His identity thus remains entrusted only to his work, born more out of the isolation of a convent than the liveliness of urban relationships.

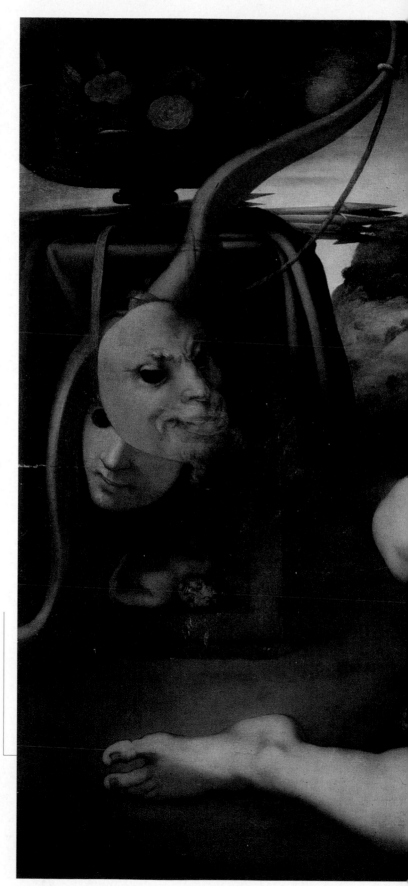

◆ VENUS AND CUPID (c. 1533, Florence, Uffizi). The work was painted by Pontormo following cartoons by one of his few friends, Michelangelo, whose hand is recognizable in the plastic force of the solid bodies. But his most faithful companion was Bronzino, whom he portrayed as a young man in *Joseph in Egypt* (1517-18, London, National Gallery, shown in the detail above).

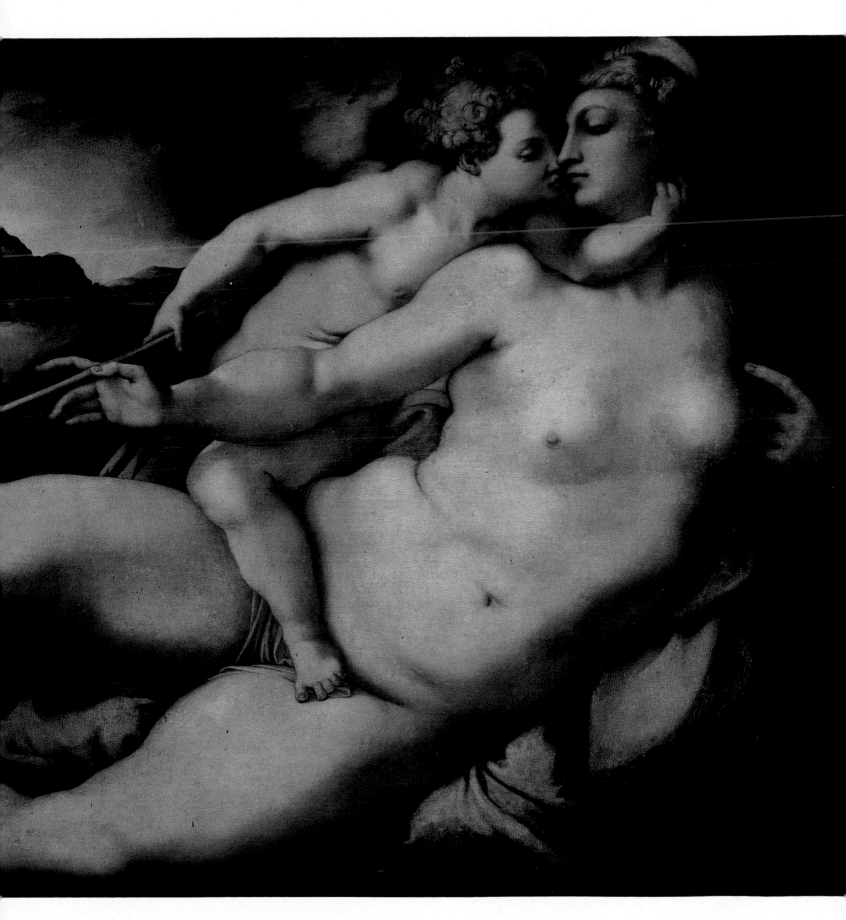

IN THE WORKSHOP OF THE BEST

Vasari recounts that Pontormo reached Florence when he was barely 13 years old and was apprenticed to Leonardo da Vinci. Reconstructions of his life date his arrival in 1506 or possibly in 1507, at a time when the city still maintained the leading role in the panorama of Italian art.

● Leonardo lived in Florence until 1508, when he moved to Milan to the Sforza court. The young Pontormo's apprenticeship was thus brief and difficult to document because of the complete lack of testimony or works dating to that period. Judging from the constancy with which Pontormo returned in the course of his life to

to the faction of the *piagnoni* (Weepers), followers of Savonarola, who even after the friar was burned at the stake continued and developed his moral criticism of the Church of Rome and the lords of Florence. By now an old man, in 1508 Piero handed the young artist into the care of Mariotto Albertinelli, another painter in the *piagnoni* faction known for his classicizing style. Of Pontormo's production in this brief period, Vasari records only an *Annunciation*, unfortunately now lost.

● In 1512 the young man joined the workshop of Andrea del Sarto, with whom he worked on the decoration of the church of the

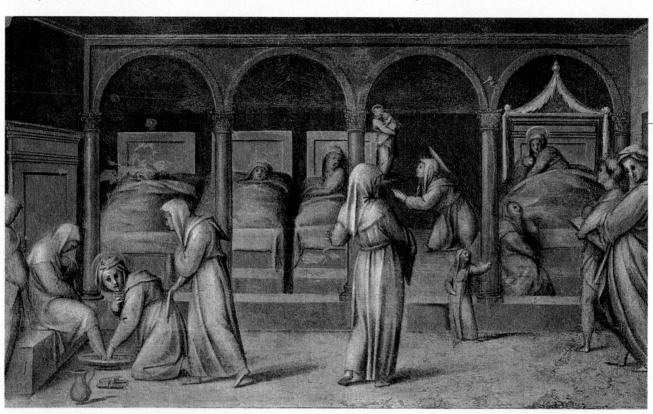

◆ AN EPISODE OF HOSPITAL LIFE (1514, Florence, Gallerie dell'Accademia) The fresco, painted using only three colors and a dry linearism, decorated the women's ward in the old hospital of San Matteo. Perhaps painted to fulfill a vow, it marks Pontormo's debut as a painter.

◆ THE VISITATION (1514-16, Florence, Santissima Annunziata). Pontormo painted the fresco in a classical, pyramidal composition and style echoing the art of Andrea del Sarto, who was working in the same church during that same period.

meditating on the solutions of the master, in particular his soft chiaroscuro, it is reasonable to think that Leonardo's experimentation made an impression on him. It is nonetheless probable that his training at the beginning was above all directed towards the study and copying of works of earlier artists, from Giotto to Botticelli, from Ghiberti to Masaccio.

● Upon his departure, Leonardo entrusted the boy to Piero di Cosimo, an extravagant painter who painted mythological scenes with a pronounced tendency towards fantasy. Piero may have been the one to suggest to Pontormo ideas which go beyond painting and invest the spiritual sphere. Piero was an adherent

Santissima Annunziata and the ephemeral works in honor of Giovanni de' Medici, elected pope with the name of Leo X. Vasari recounts that Andrea del Sarto expelled Pontormo from his shop, envious of Michelangelo's admiration for the pupil's work.

● Apart from anecdote, from 1514 the numerous works painted by the youth reveal a notable mastery of technique, if not an autonomous style. Pontormo assimilated from Andrea the compositional structures, chromatic modulation, and incisive line, but he revealed an innate tendency towards dynamism and a rupture of the classical schemes, which would be developed much further while Andrea del Sarto was in France between about 1517 and 1519.

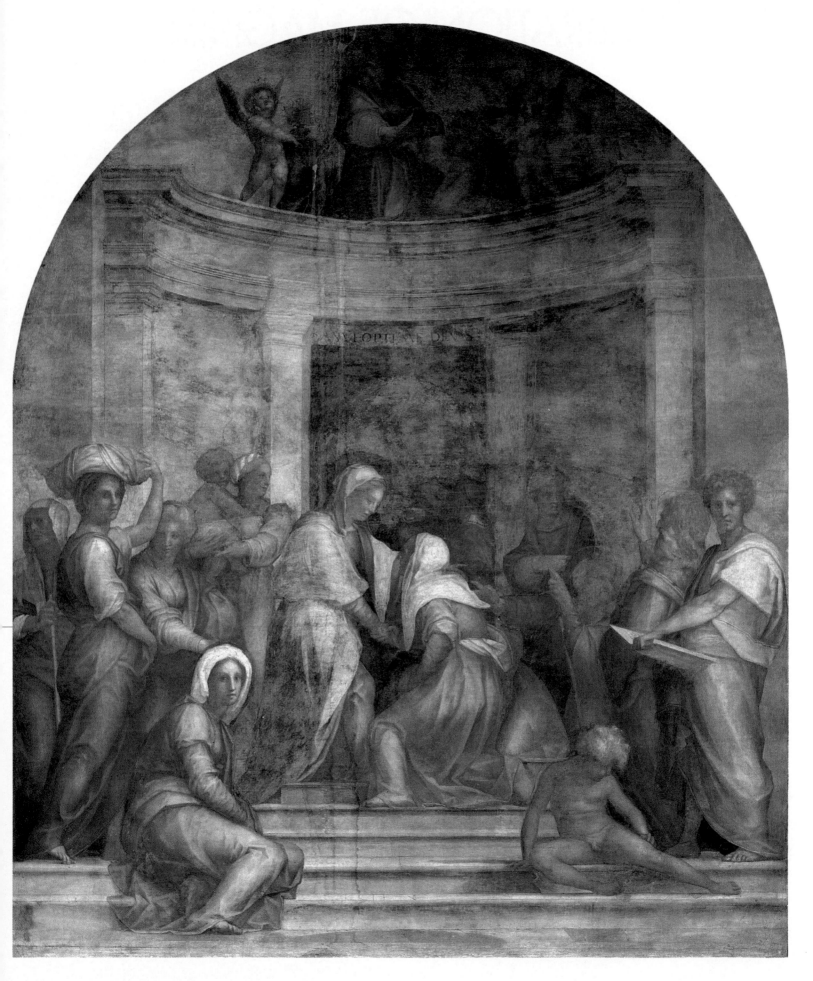

THE CELEBRATION OF MAGNIFICENCE

For an artist like Pontormo who spent his life without leaving Florence, the problem of patronage raises the question of the necessity of a relationship with the political powers. Despite his republican beliefs, the artist became a part of the cultural circle surrounding the Medici, whom he celebrated in portraits with a sometimes solemn, sometimes intimate tone. Their rule over the city, restored in 1512, curiously, marked both the beginning and the end of Pontormo's activity, as one of his first works was a coat of arms painted for the Medici in 1515, and at his death he was working for Cosimo on the frescoes of the choir of the church of San Lorenzo, the basilica under Medici patronage.

● The most outstanding personality in the family at the time was Pope Leo X, born Giovanni de' Medici. On the occasion of the pope's triumphal visit to Florence, in 1515 Pontormo participated in the deco-

◆ PUTTI AND ARMS OF LEO X (1515, Florence, Santa Maria Novella, Papal chapel). In the fresco adorning the chapel vault, the Medici arms appear next to symbols of papal power.

ration of the papal chapel in the convent of Santa Maria Novella. At the pope's behest he also began decorating the family villa at Poggio a Caiano, interrupted in 1521 by the pope's death and resumed in vain in the 1530s by Ottaviano de' Medici.

● The frescoes on astrological and philosophical themes in the villas of Careggi and Castello, realized with Bronzino, were commissioned by Alessandro de' Medici in 1535 and 1537. But, painted in oil on dry plaster, a perishable technique, they have been lost.

● Cosimo de' Medici commissioned from Pontormo the decoration of the choir in the church of San Lorenzo, on which the artist worked between 1546 and 1556. In solitude, painting and then destroying the work with which he was always dissatisfied, he finally died, leaving it unfinished. Brought to completion by Bronzino, the frescoes were irredeemably destroyed in 1742 during renovation of the choir, and only drawings remain.

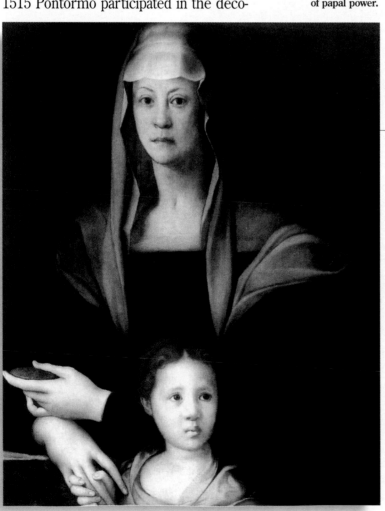

◆ PORTRAIT OF MARIA SALVIATI WITH THE YOUNG COSIMO DE' MEDICI (1537, Baltimore, Walters Art Galery). In the portrait Maria Salviati is depicted younger than she actually was at the time of the painting. Some critics contest the identification of the child as Cosimo, saying that it seems to be a girl.

◆ PORTRAIT OF COSIMO THE ELDER PATER PATRIAE (1519, Florence, Uffizi). Pontormo celebrates the Grand Duke in an evocative portrait, which explains the profile pose borrowed from medallions, the dark waxy complexion, the eulogistic laurel. The ribbon with an inscription from Virgil reads *"uno avulso non deficit alter."*

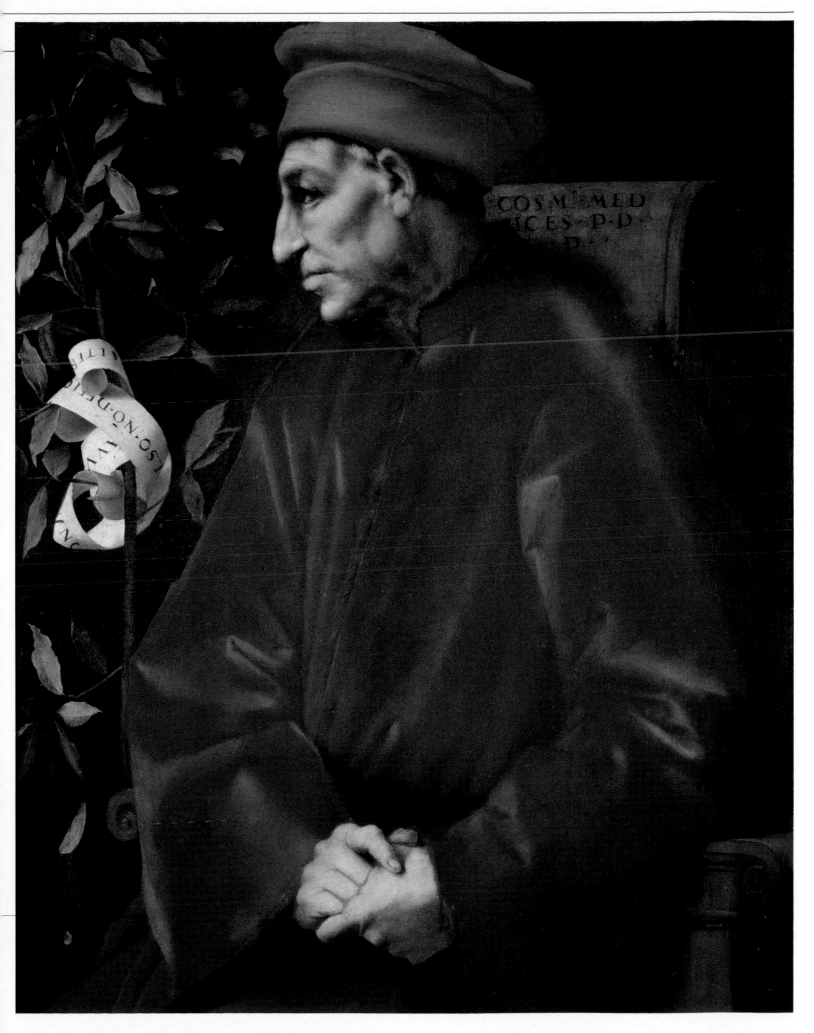

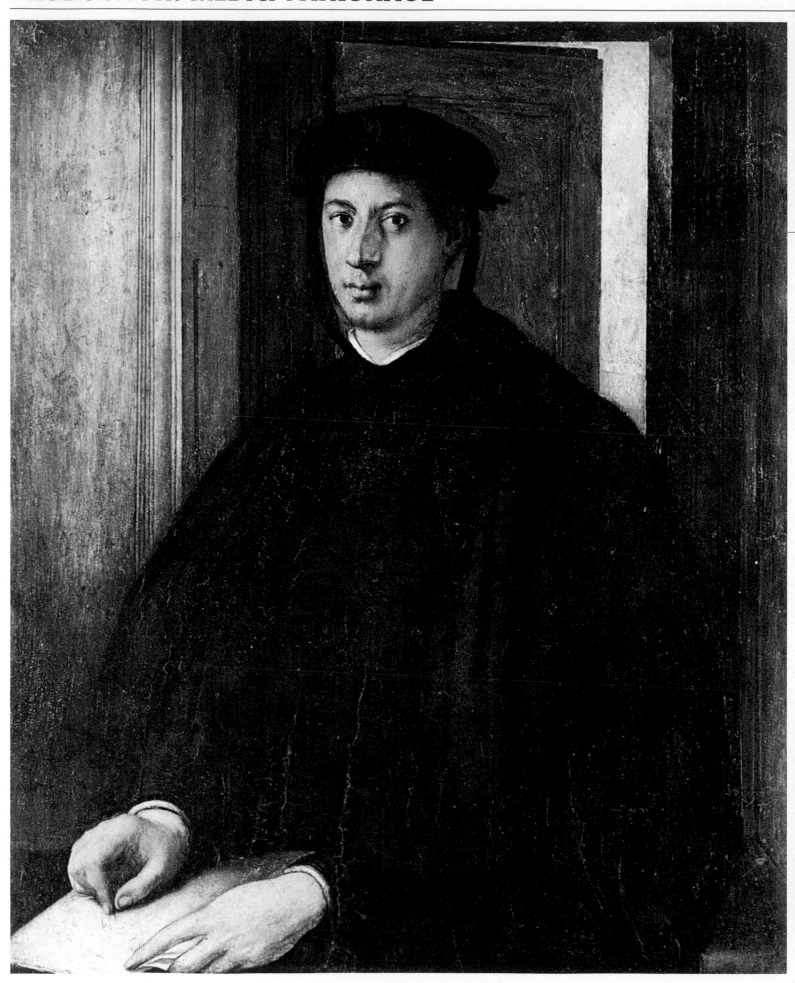

◆ PORTRAIT
OF ALESSANDRO
DE' MEDICI
(1534, Philadelphia,
Johnson Collection).
The duke is portrayed
by Pontormo, using
a muted palette and
strong contrasts of light
and shade, as he draws
a female portrait on
a sheet of paper.
Despite his fame as
a womanizer, it seems
that the sketch
on which the duke
is working should be
interpreted as an act
of homage to his future
wife. Belying the proud
cast of his head,
in Pontormo's portrait
Alessandro possesses
a certain spirituality.
The duke, murdered
in 1537, had also
entrusted to Pontormo
the decoration
of his villa at Castello.

◆ ST VERONICA
(1515, Florence,
Santa Maria Novella).
The fresco was painted
for the visit to Florence
of Giovanni de' Medici,
elected pope in 1513
with the name
of Leo X. For the pope,
who later would also
assign other works
to Pontormo,
the painter decorated
the chapel with
the Medici arms and
the image of
St Veronica, clearly
borrowing from
Michelangelo for
the torsion which
recalls the *Doni Tondo*.
Compared to earlier
frescoes, here
the palette is warmer
and the pose, while
monumental, does not
avoid a certain
theatricality. The value
of the work lies mainly
in its nature as
a milestone on the road
to Mannerism.

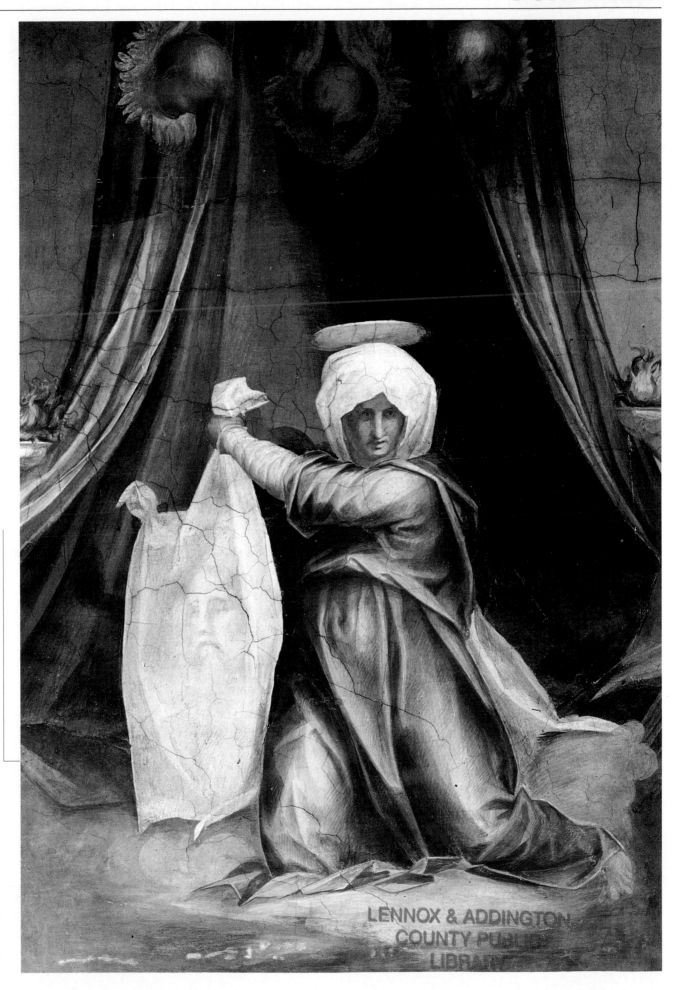

A CHALLENGE TO TRADITION

As work progressed on his great decorative cycles, Pontormo developed his new Mannerist style. On the occasion of the wedding of Pier Francesco Borgherini, in 1515 he was commissioned, along with Andrea del Sarto and Francesco Bachiacca (1494-1557) to paint some panels for wedding chests. The panels illustrate Bible stories about Joseph, with a narrative style which recalls medieval tradition: within the same scene are inserted episodes belonging to different chronological moments.

● The panel *Joseph in Egypt* is conventionally considered the beginning of Pontormo's Mannerist style; here can be found its brilliant colors, unlikely architecture, clear, cold light, and long, slender figures. But above all, here begins the fractured compositional structure which soon became characteristic of the new style: the groups clump together in cores devoid of any logical connection, the main action takes place on the edge, space is incoherent to the point of precariousness. Dominant by now is an aspiration toward a decorative effect and finely chiseled details to the detriment of overall unity.

● Commissioned also from Andrea del Sarto and Franciabigio (1482/83-1525) by Leo X and left unfinished because of the pope's death in 1521, the decoration of the Medici villa at Poggio a Caiano marks the second milestone on Pontormo's path towards Mannerism. It is based on an iconographical program prepared by the humanist Paolo Giovio; Pontormo painted between 1519 and 1521 a fresco of *Vertumnus and Pomona* in the lunette, a painting that with its serene bucolic poetry represents a unique moment in his career. Using an almost geometrically rhythmical structure and surprisingly realistic details, Pontormo utilized the mythological subject to glorify the Medici family.

● The cycle for the Certosa del Galluzzo was painted between 1523 and 1525, while he fled the plague raging in Florence. His frescoes of *Stories from the Passion of Christ* – badly damaged by the elements – reveal the influence of Dürer's engravings. For their daring foreshortening, Gothic overtones, elongated forms, and spectral light and colors, Vasari considers them to mark the beginning of the decadence of the painter's style.

◆ JOSEPH IN EGYPT (1518-19, London, National Gallery). Pontormo's Mannerism explodes in the composition of this canvas, carefully arranged as though on stage. This is the best known as well as the most luminous painting in the cycle of *Stories from the Life of Joseph*. While the gate to the city, glimpsed in the background, can be recognized from a model by Luca di Leyden (1489/94-1533), the scene is set in a fantastical architecture which disobeys the rules of perspective. The figures assume unnatural, uncomfortable poses, also due to their gestures of supplication. At times gathered into unruly crowds, at times isolated and devoid of a narrative tie with the others, they impart a syncopated rhythm to the work. The outlines are sharply defined, the palette cool, following the models of northern art.

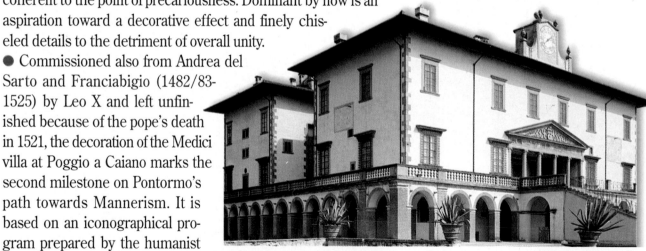

◆ GIULIANO DA SANGALLO *Medici villa* (1485, Poggio a Caiano). The villa was commissioned from the architect while Lorenzo the Magnificent was still alive, but it was finished under his son, who ascended the papal throne with the name of Leo X. Its curious ground plan in the shape of an H, the pincer-like entrance staircase, and the portico running around its entire perimeter possess the geometric but elegant simplicity typical of Medici buildings. The architecture is complemented by a cycle of decorations on the interior, on which Pontormo worked during the 1520s. In harmony with the villa's location outside the city, the painter interwove the celebration of the Medici family with rural motifs, making Poggio a Caiano a favorite spot for the rest and entertainment of the Medici court.

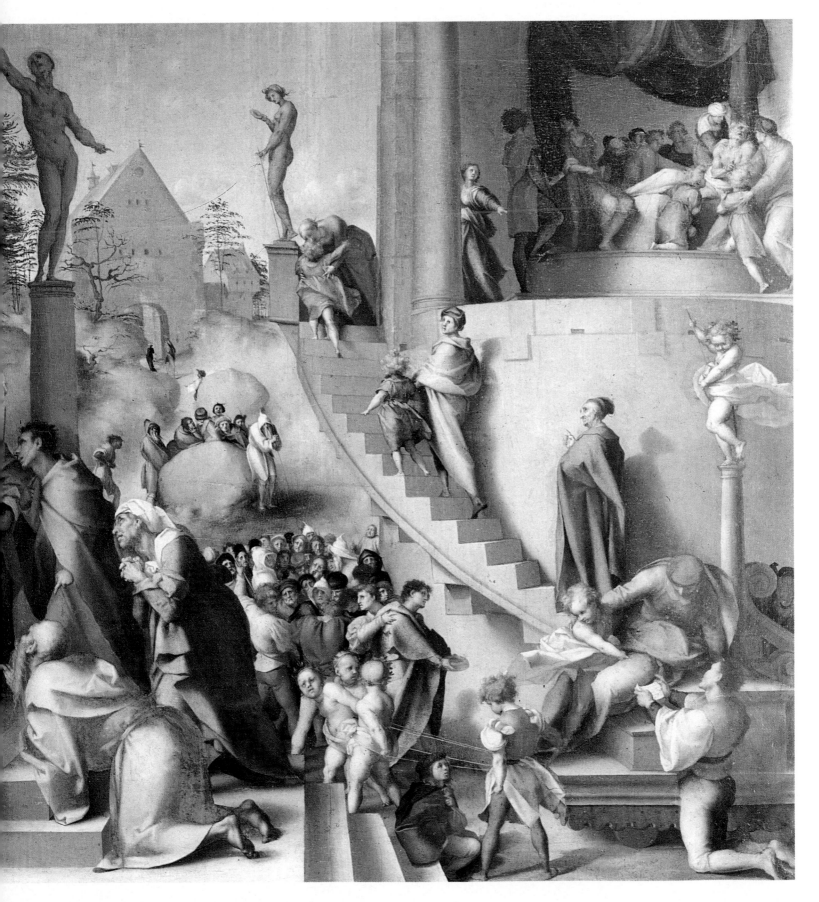

PRODUCTION: THE GREAT CYCLES

♦ CHRIST BEFORE PILATE (1523-25, Florence, Certosa del Galluzzo). Vasari records that while the plague was raging through Florence, in 1523 Pontormo took refuge in the Carthusian monastery at Galluzzo, where he received from the prior Leonardo Buonafé the commission to decorate the cloister with *Stories of the Passion of Christ.* The frescoes are considered by some to mark the beginning of Pontormo's stylistic decline. But this judgment is probably born out of a lack of understanding of the painter's choice to adopt here models borrowed from the northern prints by Albrecht Dürer, which had recently begun circulating in Florence. But while the rough, emphatic expressions of the faces, sharply defined contours, and tormented light recall Dürer, in the scene of *Christ Before Pilate* there are also traces of the Florentine tradition, especially of Filippo Lippi and Ghirlandaio, whose style is recognizable in the servant coming down the stairs. Despite the fact the foreground is occupied by a menacing fence constituted by the rhythmic placement of the soldiers and Pharisees, whose elongated figures are imposing, the spectator's eye is captured by this figure who proceeds almost as in a dance, forcing his presence onto the empty space. His position on an axis with Christ, isolated among the soldiers, generates an effect of contrast.

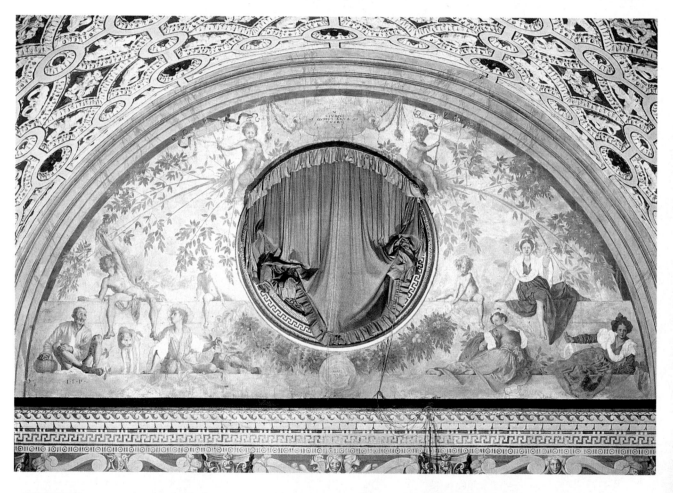

♦ VERTUMNUS AND POMONA (1519-21, Poggio a Caiano, Medici villa). Pontormo frescoed the lunette of the central salon, two stories in height, of the Medici villa at Poggio a Caiano. The rural, bucolic subject, suggested by Paolo Giovio, comes from classical mythology as narrated by Ovid. Vertumnus is a god connected with the cycle of the seasons and perhaps is Etruscan in origin, while Pomona is the nymph who symbolizes fertility and is tied to the harvest. Their love thus brings about an epoch of prosperity which, going beyond the myth, alludes to the renewed golden age inaugurated in Florence with the election to the papal throne of Leo X, son of Lorenzo the Magnificent and patron of the decoration of the villa. The pope's untimely death in 1521 caused the decoration to be suspended before Pontormo could begin the second lunette with the allegory of the arts. The rebirth of nature is celebrated symbolically by Pontormo through the laurel branches which sprout from the dead trunk and by the rich garland. The poses of Vertumnus and Pomona and the putti, some symmetrical, others mirror images, impose a certain rigor onto the scene. But the rustic clothing worn by the figures gives it a strong note of naturalistic freshness. The painter signed his work "I.F.P." – "Iacobus fecit Pontormus" – beneath the old peasant on the far left.

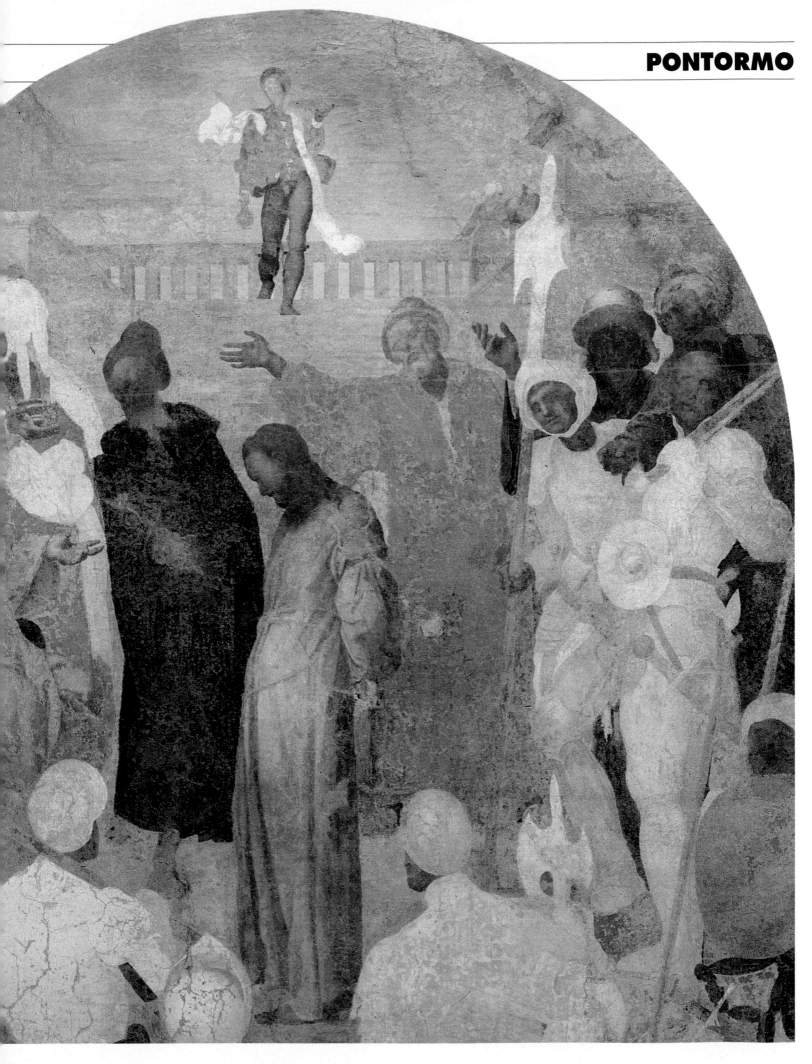

AN ANTICLASSICAL CALLING

The production of devotional panels on Marian subjects and of numerous *Sacre Conversazioni* reveals in the 1520s the progressive detachment of Pontormo's style from the teachings of Leonardo and Andrea del Sarto. The former, by this point far away from Florence, to which he paid a brief visit in 1515, died in 1519 while the latter was returning from France. The absence of the two masters in these years allowed the painter to develop his own style, and thanks also to Medici patronage, to emerge progressively as one of the leading artists in Florence.

● Until then, his works, even when the attempt is clear to find his own style, move within the lessons of Andrea's art. The *Pucci Altarpiece* is the principal work painted by the artist before 1520. Dated to 1518, it echoes Andrea del Sarto in its burnished palette, his customary pyramidal structure, and architectural setting. And yet there is an instinctive rupture in the perspective of the space, a vocation to caprice evident in the agitated figures and their degree of expressiveness. Along with the broken composition, the gestures of the figures become one of the determining factors which introduce a dynamic effect into the painting and thereby break with Classicist canons. This is the first step toward a Mannerist style.

● In *The Adoration of the Magi* of 1519-20, the artist inaugurates instead a return to a meditation on Leonardo's models, evident in the subtle chromatic shadings and the marked characterization of the faces, which are not exempt from northern suggestions. This rereading of the master's works results also in *The Penitent Saint Jerome* of c. 1527-28 and *The Virgin and Child* of 1525, which in certain aspects appear almost to be citations from works by Leonardo.

● Pontormo's masterpiece is instead *The Visitation* at Carmignano, of c. 1528, which astounds the viewer for its chromatic violence, metallic light, and rigid draperies. The figures have by now acquired a characteristic torsion, the visionary representation is rendered in strident colors. The alteration of reality is reinforced by the space of the background, which suggests Florence with a pronounced lack of proportion with respect to the figures in the foreground. The imposing nature of the sacred group united with the unreality of the vision ratifies his definitive abandonment of Classicism.

◆ THE VISITATION (c. 1528, Carmignano, San Michele). The panel is striking in its arbitrary combination of colors, but above all for the arrangement of the figures, borrowed from an engraving by Dürer. Monumental and yet on tiptoe, wrapped in swollen draperies which anticipate the Baroque, they tower over the background of 16th century style buildings.

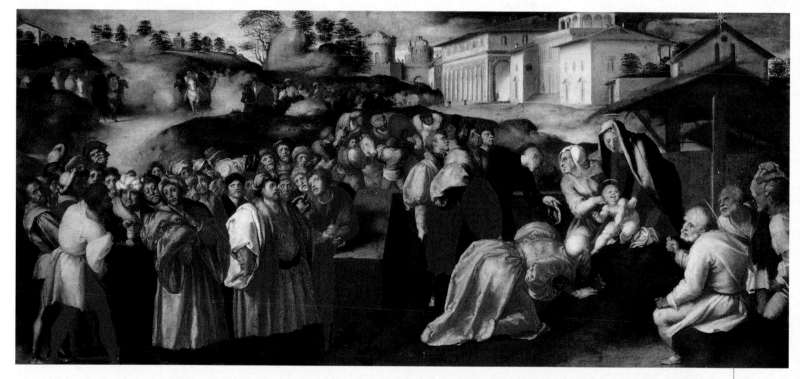

◆ THE ADORATION OF THE MAGI (1519-20, Florence, Palazzo Pitti). The panel, painted for the antechamber of Benintendi, demonstrates Pontormo's adherence to anticlassical and northern models, as is revealed especially in the almost caricatural expressionism of the faces. The first one on the left may be the artist's self-portrait.

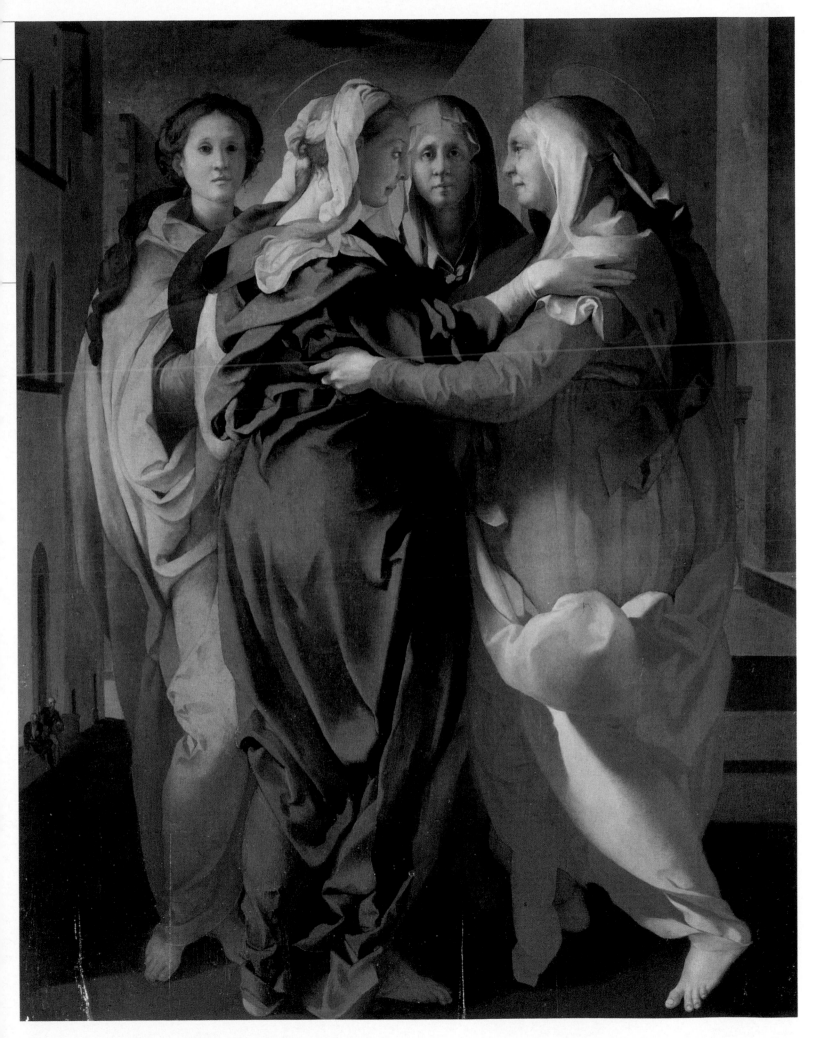

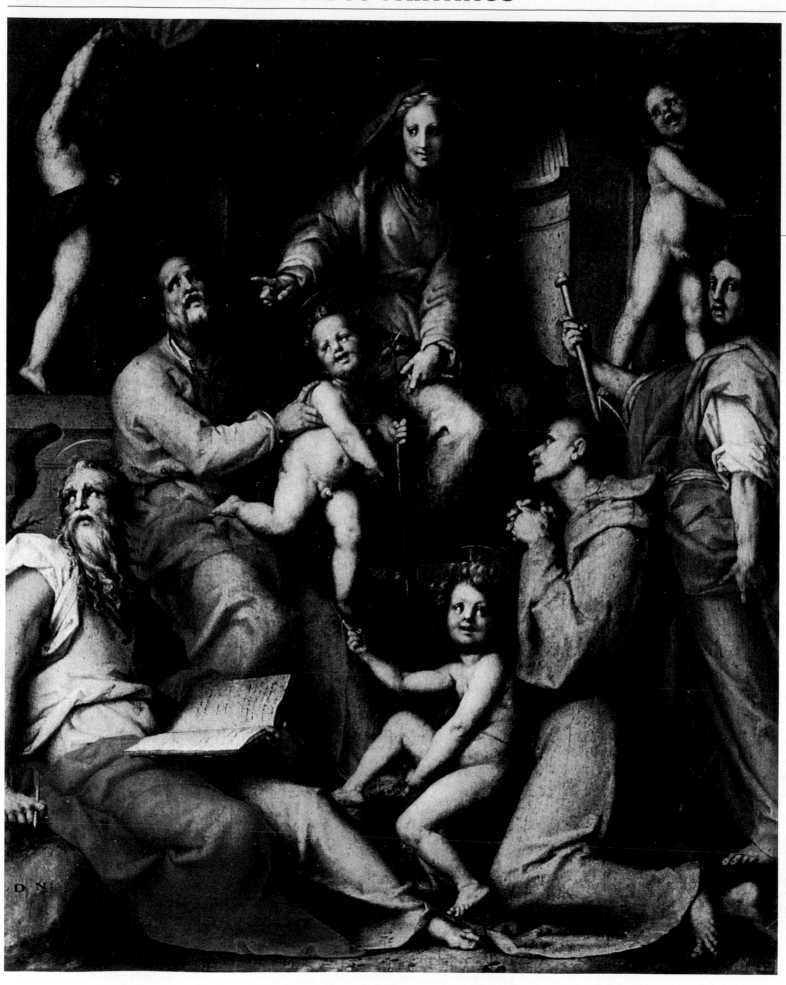

◆ THE PUCCI
ALTARPIECE
(1518, Florence,
San Michele Visdomini).
This *Sacra Conversazione*
is known as the *Pucci
Altarpiece* from
the name
of its patron, who
specified in his will
that the altarpiece be
dedicated to his name
saint Francis and to St
Joseph. Concern for
man's fate after death
is expressed
in the play of glances
and gestures among
the personages, whose
task it is to intercede
for the salvation
of the human soul.
The panel reworks
compositional models
established by Andrea
del Sarto, adding here
the pronounced
gesturing of the figures,
the bonds created
by their glances,
and the tormented light
which renders their
faces almost grotesque.

◆ THE SUPPER
AT EMMAUS
(1525, Florence, Uffizi).
The canvas was painted
for the guest quarters
at the Certosa
del Galluzzo, where
in those same years
Pontormo was also
painting fresco
decorations for
the cloister with *Stories
from the Passion of Christ*.
In the scene, treated
with realism and
naturalness, appear also
some monks from
the convent who had
become the painter's
friends. As a whole,
the style offers
a meticulous description
of the objects which
is almost
pre-Caravaggesque and
opposes a more familiar
version to the usual lofty
rendering of the theme.
The triangle with the eye
of God was added later
by Pontormo's student
Jacopo Chimenti, called
Empoli (1551-1640).

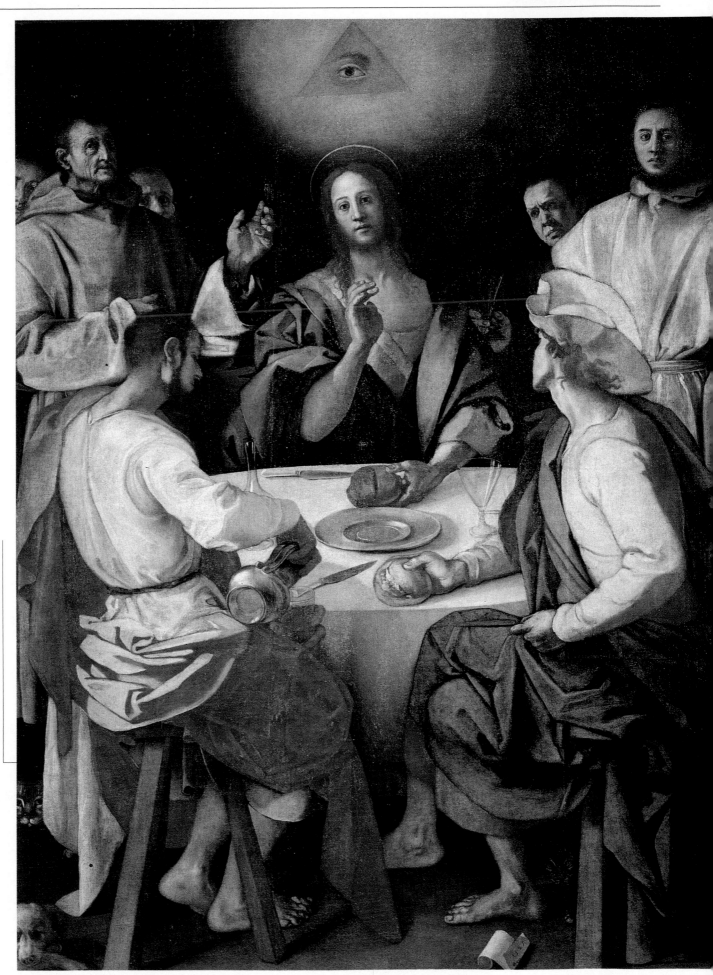

PRODUCTION: THE RELIGIOUS PAINTINGS

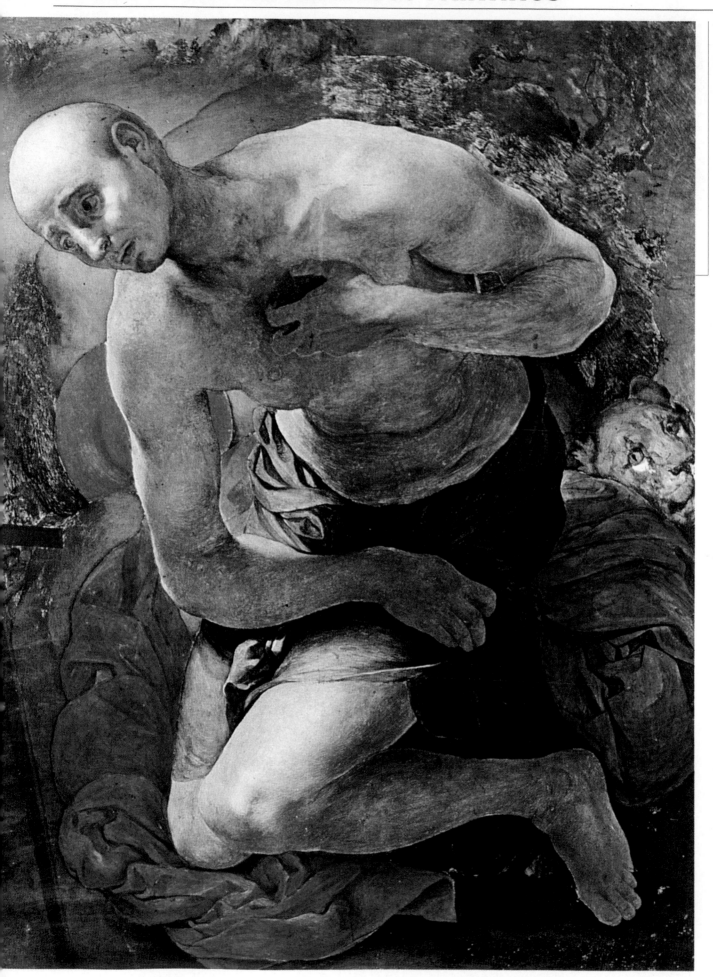

◆ THE PENITENT
ST JEROME
(1527-28, Hannover,
Niedersächsisches
Landesmuseum).
The canvas was left
unfinished because
of the unrest
in Florence, besieged
by imperial troops.
It was commissioned
by Ludovico Capponi,
for whom Pontormo
had just finished
the decoration
of the chapel in Santa
Felicita. Going against
tradition, Pontormo
describes a young
St Jerome, and
relegates the lion
to the margin
of the picture.
He utilizes cardinal red
as a violent chromatic
base to reinforce
with color the tormented
penitence of the saint,
established in
the torsion of his body,
which seems to turn
on itself.

◆ THE VIRGIN
AND CHILD
WITH THE YOUNG
ST JOHN THE BAPTIST
(1528-29,
Florence, Uffizi).
The canvas reveals
a moment of reflection,
albeit late,
on the warm luminosity
of Leonardo's paintings
and his models,
recalled also by
the Virgin's forward-
leaning pose.
Pontormo describes
intensely sweet
expressions
and imparts dynamism
to the scene
with an unusual
arrangement
of the figures that
follows the torsion
of their bodies, where
we can detect a trace
of the vigorous
plasticism
of Michelangelo.
This altarpiece often
served as inspiration
for students
in the painter's circle.

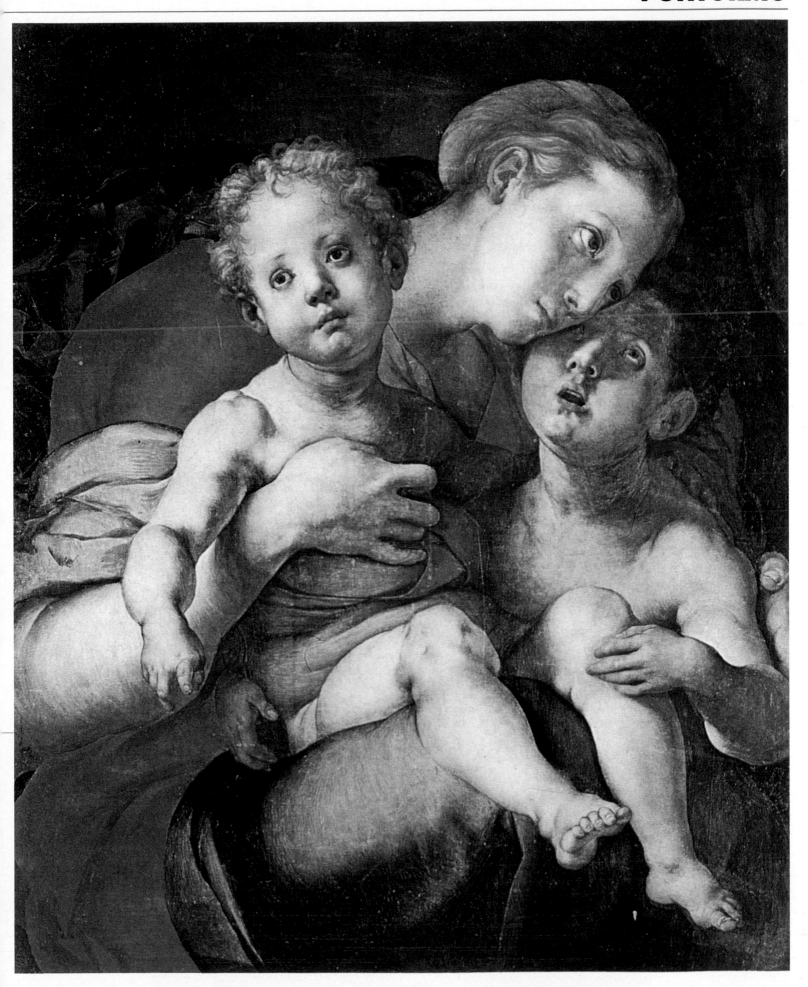

BETWEEN ELEGANCE AND INTROSPECTION

Pontormo's gallery contains a significant number of evocative portraits, whose general characteristics vary only marginally in the course of the years, while his method of framing remains constant. Besides his technical virtuosity, the painter has the merit of having proposed a new compositional layout, developed later by his pupil Bronzino, with whom sometimes confusion arises as to the correct attribution of paintings.

● The subjects, rendered in three-quarters length, in the early works stand out against anonymous dark backgrounds, drawn out of obscurity and molded by a clear light which is sometimes toned down by chiaroscuro. Subsequently the sitters are placed in a concrete space, rendered by the suggestion of architecture or a table, a parapet, a chair. They hold in their hands an object which gives the image resonance and, by attributing to them an activity (like the score in the *Portrait of a Musician*, the book in the *Portrait of Giovanni della Casa*, the weapon in the foreground of the *Portrait of a Halberdier*), makes them seem more real.

● Pontormo's early examples, like the *Portrait of a Gem Cutter*, reveal an homage to the subtly graduated light characteristic of Leonardo in his use of a soft light that

brings out the faces, in three-quarters profile, from an indistinct ground. His palette subsequently becomes more precious and moves from the warm tones still redolent of Andrea del Sarto to more brilliant, strident colors with which he models his forms.

● During this period, his portraits give an idealized view of reality, with the faces treated according to the canons of proportion and harmony dictated by classicism. Pontormo, while obeying them, still manages to impart to his models their own physiognomy and an emotional connotation that with keen psychological introspection transforms the picture into an intimate testimony of a life.

● Compared with his other production, which often has recourse to Michelangelo's models, Pontormo's portraits, particularly in the case of celebratory commissions, hark back to Raphael, but reworking the great Renaissance master's lesson in the light of his own existential restlessness.

● In his official portraits, the representation is more austere, and the subjects are described with severe, mute faces and static poses. This produces images of extreme elegance, which renders more abstract and spontaneous the dignity demanded by their sitters' role. Pontormo reduces the trappings of power in order to restore importance to the person and to discover his sitters' individuality above and beyond their political and social positions.

◆ PORTRAIT OF A WOMAN WITH A BASKET OF SPINDLES (1515-18, Florence, Uffizi). The panel is usually attributed to Pontormo, but the critic Costamagna prefers to consider it the work of Andrea del Sarto or other minor painters. The debate is still going on: while in effect the woman's bodice and sleeve recall Raphael's portrait called *La Velata*, the restless expression of her eyes and the intimate tone of the work are typical of Pontormo.

◆ PORTRAIT OF COSIMO I DRESSED AS A HALBERDIER (1537, Malibu, John Paul Getty Museum). Known as *The Halberdier*, the portrait was identified for the first time by Costamagna as Cosimo I de' Medici, but this is still the subject of debate. In the official portrait the duke, whose figure is emphasized by the clear light and brilliant colors of his uniform, appears in the guise of defender of the city, standing in front of the Fortezza da Basso.

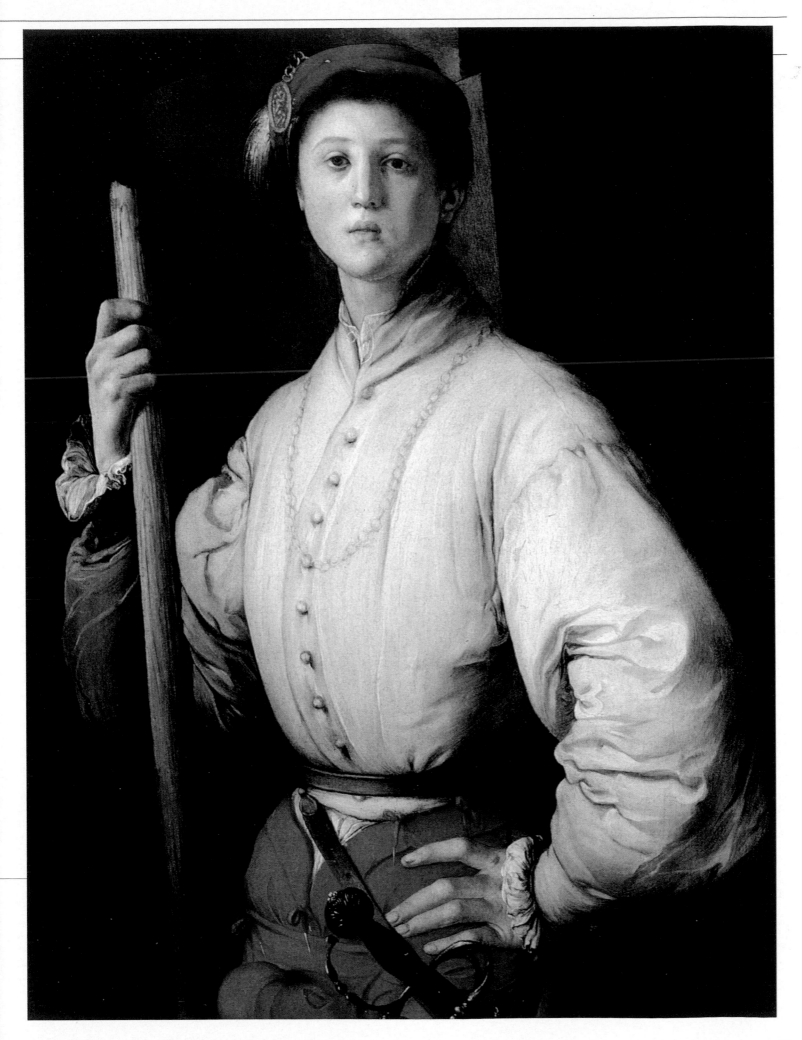

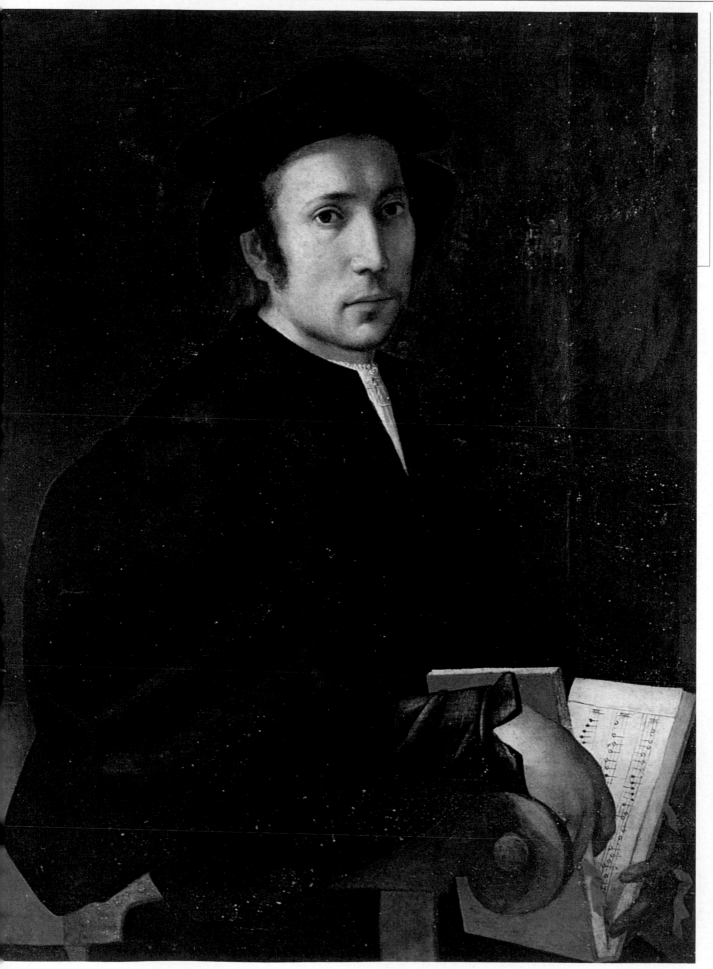

◆ PORTRAIT
OF A MUSICIAN
(1518-19, Florence,
Uffizi).
The panel depicts
the then famous
musician Ajolle or,
more probably,
Pontormo's pupil
Giovan Antonio Lappoli,
who was an amateur
musician. The sitter's
face reveals the artist's
attention to Leonardo's
chiaroscuro – typical
of his early portraits,
pervaded by dark tones
and amorphous
backgrounds –
but possesses
the introspective
power characteristic
of Pontormo.
A melancholy, sad air
soon became the norm
in his works.
The musician's
voluminous black tunic,
standing out against
the red of the score
and the chair, gives
the figure its imposing
stature, while only
the face is given
plastic force, almost
in contrast with the rest
of the body.

◆ PORTRAIT
OF A GEM CUTTER
(1518, Paris, Louvre).
The object
in the foreground, a tool
for working with gems,
has suggested that
the sitter is a jeweler.
The panel testifies to the
progressive lightening
of Pontormo's palette;
here he combines with
a composition taken
from Andrea del Sarto
Raphael's model in the
Portrait of Bindo Altoviti.
The turn
of the face, exposing
the man's determined
chin to the light, reveals
the melancholy
expression typical
of the master's portraits.
The meticulous
rendering of the man's
strong features
is in keeping with
the precious refinement
of his clothes.

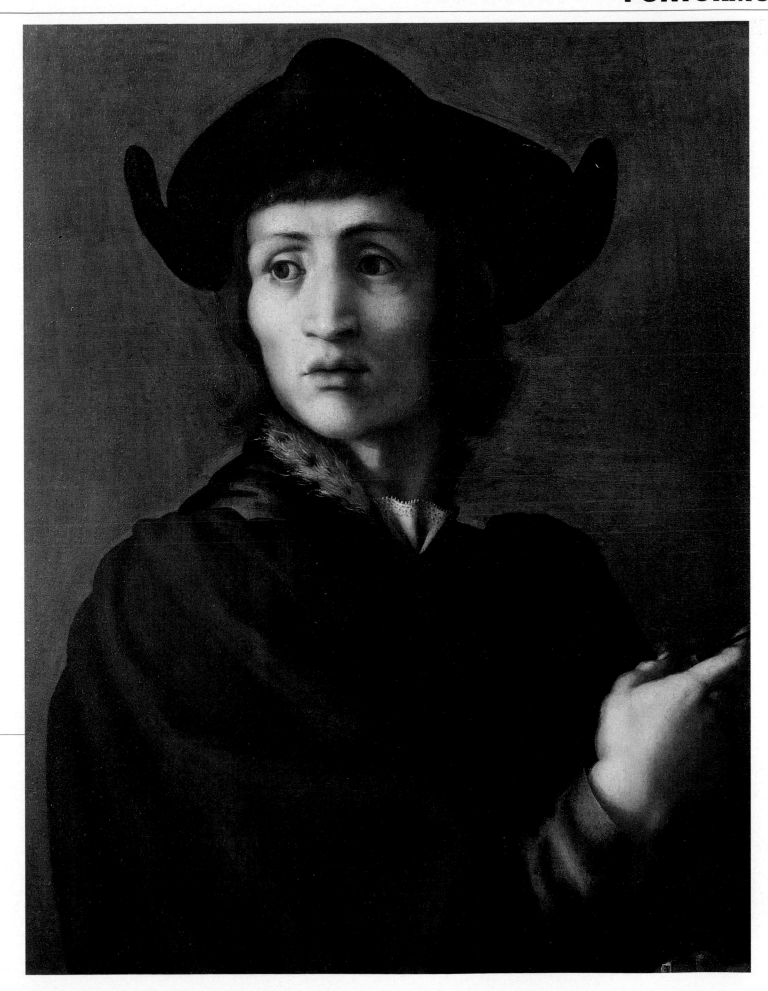

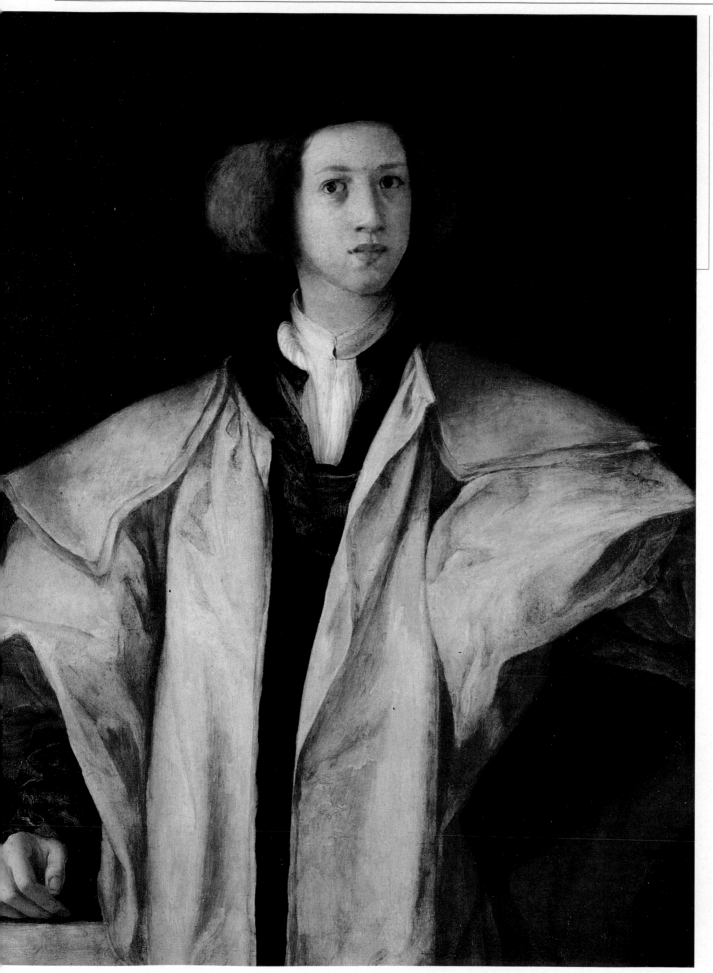

♦ PORTRAIT OF AMERIGO ANTINORI (c. 1531, Lucca, Palazzo Mansi). The young man who presents himself in Pontormo's painting in all his sumptuous elegance was an enemy of the Medici and may have been the artist's friend. This picture is the first example of a standing portrait by the master. The hand resting on the parapet and the haughty expression have their model in compositions by Sebastiano del Piombo, the Venetian painter who arrived in Florence in 1525. The denser, more heavily laden brushstroke and the even more brilliant color seen in this picture inaugurate the season of the last official portraits painted for the Medici family.

♦ DOUBLE PORTRAIT (1524, Venice, Cini Collection). This picture appears to be the only case, along with the *Portrait of Maria Salviati with her Son Cosimo de' Medici*, of a double portrait in Pontormo's production. The two men portrayed here had taken refuge from the plague in the Carthusian monastery at Galluzzo, where the painter met them. To emphasize the tie between the two, the artist placed in the foreground a letter, pointed to by the one on the left, in which a passage from Cicero's *De Amicitia* (VI, 22) can be read. The glances and pose of the two figures, who involve the spectator as a witness, are thus charged with a specific expressive connotation.

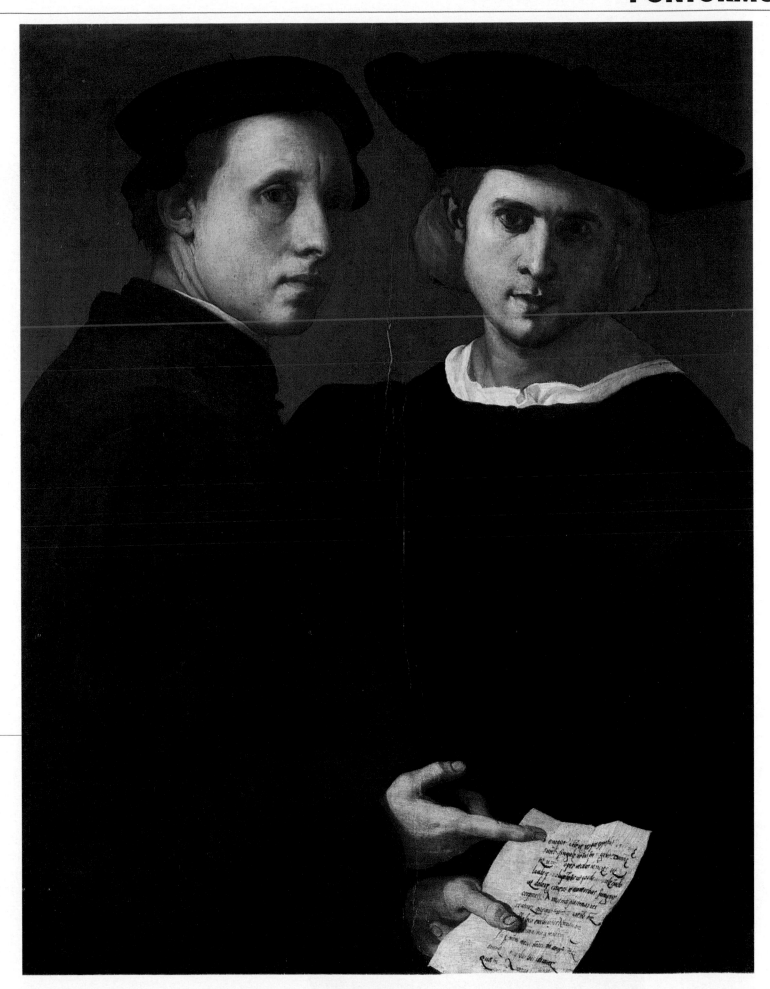

TRIUMPHS AND DEFEATS OF THE MEDICI FAMILY

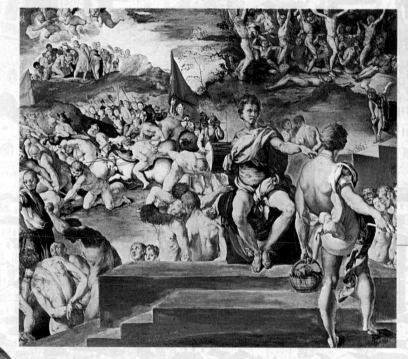

The life of Jacopo Carucci reflects the alternation of triumphs and defeats of the Medici oligarchy. When Pontormo was born in 1494, Piero de' Medici was banished from Florence and the republic established. The vehement preachings of Savonarola, who was burned at the stake in 1498, continued to spread even after his death, dividing Florence into three factions, the *piagnoni* who followed the friar, the *palleschi* who wanted the Medici's return, and the *arrabbiati*, the party of the nobility. This was the situation Pontormo found when he reached Florence at the beginning of the 16th century and joined the circle of Piero di Cosimo.

● The Medici domination of the city, restored in 1512, was echoed in its patronage when in 1513 Giovanni de' Medici was elected pope with the name of Leo X. Their return to power was celebrated by transforming the city into a teeming cultural workshop, glorifying the new golden age. Pontormo, too, was called to participate in this chorus of celebration with portraits and decorative cycles in the Medici villa at Poggio a Caiano.

● Between 1519 and 1521 Leonardo, Raphael, and Leo X all died; in Florence the plague broke out and Pontormo took refuge in Galluzzo, where he continued to work out his Mannerist style. At the same time, the rest of artistic Italy was studying the proposals of the great masters recently deceased and the stylistic daring of Michelangelo, and developed a new expressive language.

♦ **LEONARDO DA VINCI**
Young Woman with an Ermine
(c. 1485-90, Krakow, Czartoryski Museum). Pontormo learned from Leonardo, his first teacher, how to handle light, but also the elegant treatment of the human figure, lessons masterfully expressed in the *Young Woman with an Ermine.*

While in Tuscany, Rosso Fiorentino, Domenico Beccafumi, and Pontormo were its standard bearers, in Emilia it was Parmigianino who offered an extremely refined version of Mannerism.

● The Sack of Rome by the *Landesknechts* in 1527 and the expulsion of the Medici in that same year are only two of the events which give the measure of the climate of political and economic instability spreading throughout Italy. Repercussions in the sphere of artistic patronage added to the insecurity of the painters and hastened the decline of Renaissance harmony. Mannerism, behind its abstruse forms, increasingly took shape as the reflection of the cultural and historical crisis then prevailing.

● In 1530, Florence was besieged by imperial troops who restored the Medici to power. When duke Alessandro was assassinated in 1537, he was succeeded by his cousin Cosimo, Pontormo's last patron. For him, the painter frescoed the choir of the church of San Lorenzo, from 1546 to 1557. His sudden and untimely death caused the master to leave the work unfinished. As a posthumous homage from his aristocratic patrons, he was buried in San Lorenzo, the church of the Medici.

◆ PARMIGIANINO
*The Virgin
with the Long Neck*
(c. 1535,
Florence, Uffizi).
Within the sphere
of Mannerism,
Parmigianino
is a counterfoil
to Pontormo. Although
he has recourse
to similar formal
models, to his search
for dissonance
he opposes
a greater elegance.

◆ THE MARTYRDOM
OF THE TEN THOUSAND
(1529-30, Florence,
Palazzo Pitti).
In the openly
Michelangesque
modeling of the forms
and the choice of
subject – the martyrdom
on Mt. Ararat of the
converted Roman
legionaries – the panel
alludes to the siege
of Florence by imperial
troops, then in course,
and foreshadows the
fate of the Florentines.

◆ SANDRO BOTTICELLI
*The Adoration
of the Magi*
(1475, Florence, Uffizi,
detail). Botticelli,
who here paints
his self-portrait
on the edge of the scene
of the Epiphany, despite
the magnificence
of Medici commissions
soon turned toward the
tormented spirituality
of Savonarola, to which
Pontormo was
introduced through
Piero di Cosimo.

BOLD PRECIOUSNESS

C ritics have condemned Pontormo mercilessly for his style, which defies classical tradition with the boldness of his formal license. Because of this incomprehension, the heirs to his art are few and are limited for the most part to the Florentine world. In his workshop – where the collaboration of the artists makes it sometimes very hard to attribute the works – were minor painters like Giovanmaria Pichi, who soon preferred the monk's cowl to the painter's brush, and Battista Naldini, who in the decoration of the studiolo of Francesco I in Palazzo Vecchio recovered the light brushstroke and melancholy vein of the master, but elsewhere manifested a more decisive use of color along with a monumental structure.

● The master's heir *par excellence*, as well as one of his few friends and confidants, is Agnolo Bronzino, who entered his shop as a

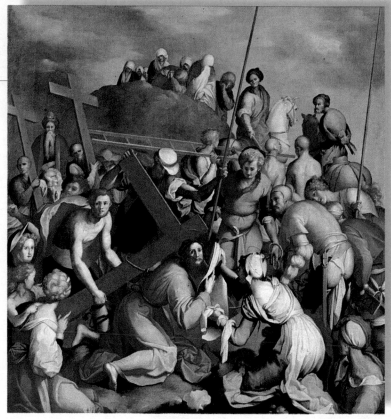

◆ BATTISTA NALDINI
The Way to Calvary
(c. 1566, Florence, Certosa del Galluzzo). Naldini, a student of Pontormo, copied the master's scene of the *Pietà* in a more descriptive style.

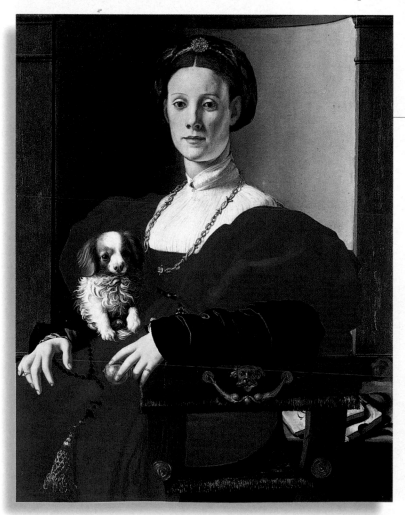

◆ AGNOLO BRONZINO
Woman with a Dog
(1532-33, Frankfurt, Städelsches Kunstinstitut). For its stylistic affinity, the canvas was for a long time attributed to Pontormo.

young boy and stayed there for the rest of his life as an autonomous co-worker. In his portraits Bronzino reproposed and exalted the compositional structure and style of Pontormo in an imitation that is hard to distinguish from the work of the master. It is especially in his use of the cool range of the palette, the careful rendering of details made precious for their own sake, the brilliant, almost aggressive colorism, and the sharply defined linearism that the greatest assonance with the master's work is manifested.

● Mannerist culture was rediscovered in the 1920s by the German neorealist movement called *Neue Sachlichkeit*. This style, which although almost clinically transcribing reality arbitrarily exaggerates shapes and colors, has its manifesto in the work of Christian Schad (1894-1982).

● A last faint echo of Mannerism can be heard in the cinema of Pier Paolo Pasolini, who in his film *La ricotta* of 1963 uses, for a satire on contemporary customs, two *tableaux vivants* with the *Depositions* by Pontormo and Rosso Fiorentino.

◆ CHRISTIAN SCHAD
Self-portrait with Model
(1927, private collection). With disquieting effects, the painter here presents the motif of the transparent green cloth borrowed from Pontormo's *Deposition*, as well as his sharply defined style.

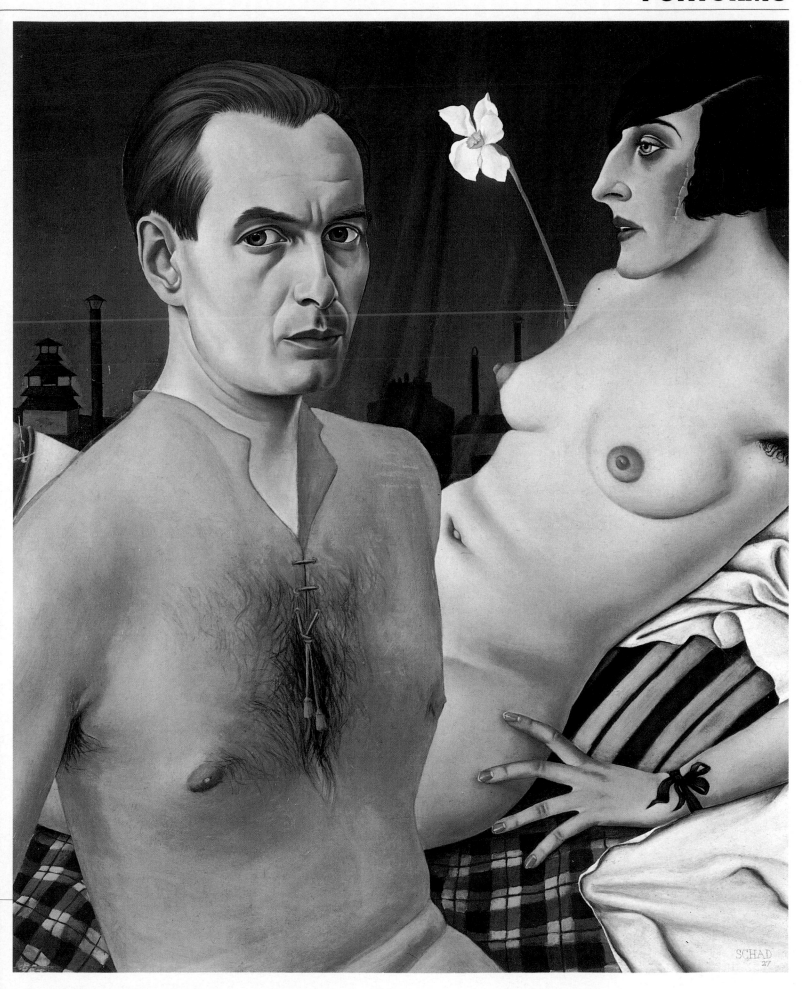

THE ARTISTIC JOURNEY

For a vision of the whole of Pontormo's production,
we have compiled a chronological summary of his principal works

◆ AN EPISODE OF HOSPITAL LIFE (1514)

Created as a votive image after a healing, the work decorates a wall of the Accademia which was once part of the women's ward of the former hospital of San Matteo. The fresco echoes in its paratactic structure 15th century arcades and the models of Fra' Bartolomeo and Andrea del Sarto. Based on the use of just three colors and a dry linearism, it marks Pontormo's artistic debut.

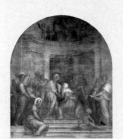

◆ THE VISITATION (1514-16)

The fresco was commissioned by the Servite friar Jacopo de' Rossi, protector also of Rosso Fiorentino, to complete the cycle of *Stories from the Life of the Virgin* in the small cloister of the church of Santissima Annunziata. Although starting with a classical, serene pyramidal composition, reminiscent of Andrea del Sarto and Fra' Bartolomeo, Pontormo renders the scene restless and dynamic.

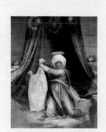

◆ ST VERONICA (1515)

Painted inside the papal chapel in the monastery of Santa Maria Novella, the fresco was commissioned for the visit to Florence of Leo X de' Medici, elected pope in 1513. Besides the lunette of St Veronica, who in the torsion of her body clearly reflects its source in the Virgin of Michelangelo's *Doni Tondo*, Pontormo also painted the putti in the vault.

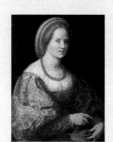

◆ PORTRAIT OF A WOMAN WITH A BASKET OF SPINDLES (1515-18)

Attribution of this panel, wavering between Andrea del Sarto and Pontormo, was long a subject of debate, a fate shared by numerous works by Pontormo which in stylistic affinity are hard to distinguish from paintings by his teacher. In Andrea's *bottega*, Pontormo practiced by copying the master's paintings, and the influence of his model remained with him in his early works.

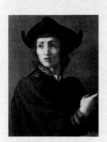

◆ PORTRAIT OF A GEM CUTTER (1518)

The portrait offers an evocative image of an unidentified young man, but the burin in his hand suggests his trade. Stylistically the work recalls the production both of Leonardo and of Raphael: the former in the *sfumato* technique and the soft light which draws out of the darker background a face with individual characteristics; the latter in the compositional structure.

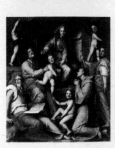

◆ THE PUCCI ALTARPIECE
(*SACRA CONVERSAZIONE*) (1518)

Painted for Francesco di Giovanni Pucci, *gonfaloniere* of the Florentine republic and Medici supporter, the altarpiece was commissioned for the church of San Michele Visdomini. The presence of St Francis and St Joseph in the scene is explained by the patron's name saints. The face of the young St James may be a self-portrait of the artist.

◆ JOSEPH IN EGYPT (1518-19)

This is the best known panel of the series of *Stories of Joseph*, painted for the nuptial chamber of Pier Francesco Borgherini. Andrea del Sarto also participated in the decoration of the room in the Borgherini family palace on Borgo Santi Apostoli. In its new compositional structure, unnatural, staged pose of the figures, and cool palette, the work marks the beginning of Mannerism.

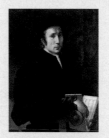

◆ PORTRAIT OF A MUSICIAN (1518-19)

The young man, identified as a musician by the score, is modeled with strong plastic force, seen especially in the folds of his clothes and his face, demonstrating Leonardo's lesson in the handling of chiaroscuro. A proposed identification of the sitter is Giovan Antonio Lappoli, a student of Pontormo and a music lover. Details whose handling is uncertain, like the chair, have suggested the hypothesis that the artist may have reworked a painting by his pupil.

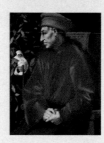

◆ PORTRAIT OF COSIMO PATER PATRIAE (1519)

The portrait, now in the Uffizi, describes an idealized appearance of Cosimo the Elder, following the typical schemes of 15th century medallions. The evocative nature of the work is manifested in the sitter's body, which disappears beneath his ample red tunic, and his dark, waxy complexion. The laurel in the background underlines the celebratory intent of the painting. The scroll bears a quotation from Virgil, "*uno avulso non deficit alter*."

◆ THE ADORATION OF THE MAGI (1519-20)

The panel, now in Palazzo Pitti, was commissioned for the antechamber of Giovan Maria Benintendi. In the treatment of the faces Pontormo borrows both from northern tradition, for the characterization of the features, and from Leonardo da Vinci for the soft handling of the light. The first figure on the left, turning toward the spectator, although slightly caricatural, could be a self-portrait.

◆ VERTUMNUS AND POMONA (1519-21)

The fresco is the only decoration Pontormo finished for the Medici villa at Poggio a Caiano before the death of Leo X, who commissioned the work through Ottaviano de' Medici. The subjects, which follow an iconographical program drawn up by Paolo Giovio, borrow mythological figures from the narrative of Ovid and were intended to celebrate the magnificence of the family. The bucolic theme alludes to the serenity of the golden age brought about by Medici rule.

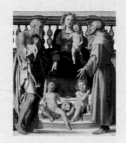

◆ VIRGIN AND CHILD WITH SAINTS (c. 1522)

The panel now in the Uffizi represents a typical example of problems of attribution. It is assigned to Pontormo by the most recent critics, but various scholars, who see in it the uncertain hand of a student, perhaps Mirabello Cavalori or the early Bronzino, still refuse to put it in the master's catalogue. Similar difficulties are presented by other cases, like the *St Anne Altarpiece*.

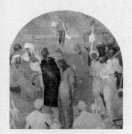

◆ CHRIST BEFORE PILATE (1523-25)

The fresco is part of the decorative cycle at the Carthusian monastery in Galluzzo, where Pontormo sought refuge in 1523 from the plague raging through the city. The painting is now seriously dilapidated by the elements. The harsh style dominating the cycle derives from suggestions taken from the engravings of the *Great Passion* by Dürer, with which the painter was familiar from prints recently circulating in Florence.

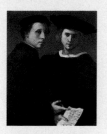

◆ DOUBLE PORTRAIT (1524)

This double portrait, whose sitters are the son-in-law of Beccuccio Bicchieraio and an unidentified man, celebrates the value of friendship, expressed in the close juxtapositon of the figures and the gesture of the hand, which points to a passage from Cicero's *De Amicitia*. The gazes and poses of the two figures, who call the spectator to witness, are thus charged with a specific emotional connotation.

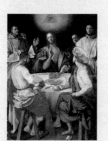

◆ THE SUPPER AT EMMAUS (1525)

Commissioned by the Carthusian monks, the picture describes a meal like the many in which Pontormo took part in their monastery in Galluzzo. His stylistic referent here, as in the *Stories of the Passion of Christ,* is the work of Dürer, who provided the model for the naturalism and the spare definition of the forms. The disproportion between the head and bodies of the figures is a Mannerist trait.

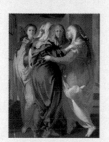

◆ THE VISITATION (c. 1528)

Painted for the church of San Michele in Carmignano, the panel is one of the masterworks of Pontormo and of Mannerism. The palette is metallic, playing on the juxtaposition of clashing colors, the light is cold, there is an evident disproportion between the small faces and the bodies enveloped in full, heavy draperies. The figures, monumental even though on tiptoe, dominate the background of 16th century buildings.

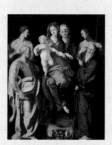

◆ THE VIRGIN AND CHILD WITH ST ANNE
BETWEEN ST PETER, ST SEBASTIAN,
THE GOOD THIEF, AND ST BENEDICT (1528-29)

The panel is also known as the *St Anne Altarpiece,* as it was commissioned by the Medici for the nuns of Sant'Anna in Verzaia for the procession of 26 July 1529 celebrating the expulsion in 1343 of the tyrant Gualtieri di Brienne, duke of Athens. The medallion bears the images of members of the Medici family.

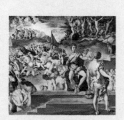

◆ THE MARTYRDOM OF THE TEN THOUSAND
(1529-30)

The work, on an unusual theme, echoes the horror of the siege of Florence during those years by imperial troops. The Bible story recounted is that of the martyrdom on Mount Ararat of the 10,000 Roman legionaries who converted to Christianity and were killed by order of the emperor Hadrian. The strong plastic force of the figures, especially the one in the center, derives from Michelangelo.

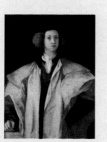

◆ PORTRAIT OF AMERIGO ANTINORI (c. 1531)

The panel was painted during the years of the Florentine republic and portrays in all his sumptuous elegance Amerigo Antinori, an adversary of the Medici family as famous as he was ferocious, who was exiled upon restoration of Medici rule. This is the only commission executed by Pontormo during this period for a private citizen. The painting is also his first example of a standing portrait.

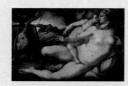

◆ VENUS AND CUPID (c. 1533)

Along with the *Noli me tangere*, this work was painted by Pontormo following cartoons by Michelangelo. The friendship between the two artists and their mutual esteem – testified by Vasari – here finds further confirmation. It has been posited that Bronzino also took part in the execution of this *Venus and Cupid*; he later treated the theme in various pictures, and may here have been responsible for the small figure and flowers on the left and the landscape.

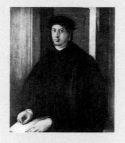

◆ PORTRAIT OF ALESSANDRO DE' MEDICI (1534)

The painting in which Pontormo portrays the duke has been seriously damaged. Alessandro, who in 1531 re-established Medici rule after the period of the Florentine republic, is depicted in the act of painting a female face, perhaps that of Taddea Malaspina to whom the work was donated. He has the aspect of the ideal gentleman theorized by Castiglione, but the image captures the characteristics of his face with psychological realism.

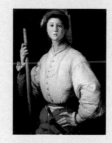

◆ PORTRAIT OF COSIMO I DRESSED
AS A HALBERDIER (1537)

The portrait, often generically entitled *The Halberdier*, probably represents Cosimo I de' Medici in uniform, as though to underline his active role in the city's defense; the uniform he wears seems to be that of the republican militia. However, identification remains uncertain. The panel is now in the John Paul Getty Museum in Malibu.

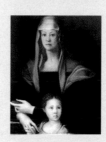

◆ PORTRAIT OF MARIA SALVIATI WITH
THE YOUNG COSIMO DE' MEDICI (1537)

The identification of the child as Cosimo at the age of seven is not accepted by everyone; some critics feel that the portrait is of a little girl. The panel was made as a *pendant* to the *Portrait of Cosimo I Dressed as a Halberdier* at the request of the duke himself. Maria Salviati, Cosimo's mother, is shown younger than she was in reality.

◆ PORTRAIT OF COSIMO I DRESSED
IN THE SPANISH MANNER (1538-39)

Ascending to power after the murder of his cousin Alessandro, Cosimo I married Eleonora of Toledo. The Spanish cut of his clothes seems thus to suggest that his future wife was the recipient of the painting. Cosimo I is not portrayed as a political man, but as a Renaissance gentleman, elegant and erudite, as indicated by the book in his hand.

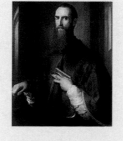

◆ PORTRAIT OF GIOVANNI DELLA CASA (c. 1540)

The subject has also been identified as Niccolò Ardinghelli, and the current attribution of identity – perhaps the most authoritative – is not unanimously accepted. Certainly Pontormo represents here the dignity assigned to the intellectual in 16th century society. The majestic figure of the sitter is captured inside a setting of medieval architecture, perhaps the monastery of Bosco ai Frati.

◆ BENEDICTION OF THE DESCENDANTS OF
NOAH (1545-56)

From 1546 to his death, Pontormo worked, amidst constant difficulty and revisions, on the decoration of the choir of San Lorenzo, the church under Medici patronage, commissioned by Cosimo I. Finished by Bronzino, the frescoes were destroyed in the renovations of the choir in 1742. Strong overtones of Michelangelo dominate the style of the late Pontormo.

TO KNOW MORE

The following pages contain: some documents useful for understanding different aspects of Pontormo's life and work; the fundamental stages in the life of the artist; technical data and the location of the principal works found in this volume; an essential bibliography

DOCUMENTS AND TESTIMONIES

Pontormo's diary

"1555. 19th of May, Sunday, I lunched and dined with Bronzino and during the morning planted those peach trees. Monday I began that arm of the above mentioned figure which looks like this – and in the evening I supped on 10 ounces of bread, eggs, and peas.
Tuesday that other arm.
Wednesday the 22nd the torso, and Thursday, which was the Feast of the Ascension, I lunched with Bronzino and in the evening with Daniello.
Friday that leg; ten ounces of bread, a fried egg, and I finished the figure.
Saturday evening I supped on a salad and two eggs – during the day I did some letters.
Sunday morning I went to San Francesco and then lunched at Daniello's house and in the evening did not eat.
Monday
Tuesday
Wednesday I did that head that is under that figure, like this [sketch of the figure]
30th of May, Thursday, the leg
Friday those backs
Saturday I finished the figure, I dined with Bronzino, it was the evening of the Feast of the Holy Spirit
[…]
1556. Thursday evening I dined with the Prior of the Innocents, he and I alone, on gelatin and eggs.
Friday the 10th [of January] at midnight a cart forced me against a wall at the knees; and Ba[stian]o came to my house to get money from Lattanzio.
Saturday I had two scudi and took them to the friars for the rent.
Sunday it rained and there was a great wind and cold all day long and I began to eat by myself a piece of roast pork; and so Tuesday went to Gello's shop; Wednesday the 15th in the evening, Bron[zino] came to my house with Ottaviano to get me to go to dinner with them; and I left him at the barber's and he didn't see me again. [...]

The morning at San Pietro and late in the evening Br[onzino] and Ataviano came by – and the farm manager let them in – but without staying; he only said – what news of Jacopo –. Then around 9 o'clock Attaviano came to knock, asking for me, saying that Alesandra wanted me – the farm manager says.
On the 20th [...] Ba[stian]o. Monday it rained all day long; great gusts and thunder and lightning, and in the evening I dined with some leftover gravy and roast pork left over from Thursday, cooked greens, 9 oz of bread and 4 oz of rosemary rolls. [...]
On the 26th, returning home at 7 p.m. I was joined by Ataviano, Daniello and Alezandra and other women who came to get me to go to dinner at Br[onzin]o's house; we went and stayed there until 7 a.m. [...]
Monday evening at Daniello's house, we went to see the play in Via Magio.
Tuesday it was very cold and snowed during the night, and I ate cabbage for supper at my house.
Wednesday
On Thursday the 20th I did that head that is shouting and I ate veal for supper and up to the 29th I got everything finished all the way to the ground which is under that head.
March 3rd I did the head of that figure drawn here.
On March 4th I did a piece of torso up to the bosom and I suffered the cold and wind so much that at night I was hoarse and the next day I was not able to work."

[Diary of Jacopo Pontormo kept while he was painting the choir of San Lorenzo, 1554-56]

A solitary man

"In a word, this painting by Jacopo [the choir of San Lorenzo] is wonderful in color, noble in design, and rare in its effect of relief; and if to these virtues, by which the figures are marvelous above all other, were to be added excellence in imitation [of reality], this would indeed be a peerless work."

[F. Bocchi, Le bellezze della città di Firenze, 1591]

"Pontormo had very beautiful manners, and he was so afraid of death, that he would not even hear it spoken of, and avoided having to meet dead bodies. He never went to festivals or to any other places where people gathered together, so as not to be caught in the press; and he was solitary beyond all belief. At times, going out to work, he set himself to think so profoundly on what he was to do, that he went away without having done any other thing all day but stand thinking."

[G. Vasari, Lives of the Painters, Sculptors, and Architects, first Italian edition 1568, English translation 1912]

The San Lorenzo frescoes

"Michelangelo, seeing some works by this young man, predicted that he would take painting to new heights, a prophecy like so many prophecies. He turned out to be a miscontent, unhappy with himself; he was always changing his style, he undid and redid and was always off the path. He worked following the taste of Albrecht Dürer. Untamed and bizarre in temperament, he had a little house built for himself that one entered through the window, and then he would pull the ladder inside. He did not want to work for the Duke, and he painted pictures which he gave to the stonemasons as payment. He took from Salviati the project for the chapel in San Lorenzo: he worked on it for twelve years, rubbing out, polishing, undoing, repolishing: finally uncovered, the masterpiece was acclaimed magnificent."

[F. Milizia, Dizionario delle belle arti del disegno, II, 1797]

"On the walls of the Choir [of San Lorenzo] can be seen two frescoed stories by Jacopo from Pontormo: one of the Flood and the other of the Resurrection of the Dead. He went mad, Vasari seems to hint, before he lifted his brush away from it, entangling himself in considering too lifelike and reproducing as natural expressions, the characteristics of those sad and dreadful events, that in truth the foreshortening is exaggerated and the attitudes tormented."

[F.L. Del Migliore, Firenze città nobilissima illustrata, 1684]

1494. On May 26 Jacopo Carucci was born in Pontorme near Empoli. His father Bartolomeo, a painter who had worked with Ghirlandaio, died in 1499; his mother, Alessandra di Pasquale, in 1504.

1508. His presence in Florence is documented, where his grandmother, "Mona Brigida," had entrusted him to public care. It is probable that he arrived in the city in 1506, when he began an apprenticeship in the workshop of Leonardo da Vinci. He then passed into the shop of Piero di Cosimo and subsequently to that of Albertinelli, it seems in 1508.

1512-13. The student of Andrea del Sarto, he participated with the master in the decoration of Carnival cars. Met the painter Rosso Fiorentino.

1515. Painted other works for festivals to celebrate the triumphal entry of Leo X, the Medici pope, into Florence. For that occasion, painted the papal chapel in the convent of Santa Maria Novella. Although undocumented, it is thought he made a brief trip to Rome, at the behest of the Florentine pope.

1518. Painted the *Pucci Altarpiece* for the church of San Michele Visdomini, one of his most important early works.

1519. Began work at the Medici villa of Poggio a Caiano, painting the lunette with *Vertumnus and Pomona*, which he finished in 1521.

1523-25. Took refuge from the plague in the Carthusian monastery at Galluzzo. With him was his friend and student Agnolo Bronzino. In the cloister he painted frescoes of *Stories from the Passion of Christ* in a harsh style with northern overtones, which for Vasari marked the beginning of his stylistic decline.

1526. Along with Bronzino, began the decoration of the Capponi chapel in Santa Felicita, which he continued until 1528.

1531. Clement VII, another Medici pope, commissioned him to finish the frescoes in Poggio a Caiano, but the project remained at the preparatory stage.

1535. Painted the portrait of Alessandro de' Medici, and with Bronzino painted the decorations for the villa at Careggi.

1537. Commissioned by Cosimo I to decorate the villa at Castello, which he finished in 1541.

1546. Began the decoration of the choir in San Lorenzo, on a commission from Cosimo I. The cycle, completed at his death by Bronzino, was destroyed in 1738 in the restoration of the church.

1557. Died on January 2 and was buried in the church of San Lorenzo.

The following is a catalogue of the principal works by Pontormo conserved in public collections. The list of works follows the alphabetical order of the cities in which they are found. The data contain the following elements: title, dating, technique and support, size in centimeters, location.

BALTIMORE (UNITED STATES)
Portrait of Maria Salviati with the young Cosimo de' Medici,
1537; oil on panel, 87x71;
Walters Art Gallery.

CARMIGNANO (ITALY)
Visitation,
c. 1528; oil on panel, 202x156;
Pieve di San Michele.

MEXICO CITY (MEXICO)
Virgin and Child,
c. 1525; oil on panel, 88x64;
Museo de San Carlos.

DIJON (FRANCE)
Holy Martyr,
1516; oil on panel, 65x48;
Musée des Beaux-Arts.

FLORENCE (ITALY)
Episode of Hospital Life,
1514; fresco, 91x150;
Gallerie dell'Accademia.

Madonna of San Ruffillo
(*Sacra Conversazione*)
c. 1514; fresco, 223x196;
Santissima Annunziata, Chapel of St Luke.

Visitation (decoration for the car of the Mint),
1514; oil on panel, 69x53;
Palazzo Vecchio.

St Veronica,
1515; fresco, 307x413;
Papal chapel, Santa Maria Novella.

Portrait of a Woman with a Basket of Spindles
1515-18; oil on panel, 41x33;
Palazzo Pitti.

Pucci Altarpiece (*Sacra Conversazione*)
1518; oil on panel, 214x185,
San Michele Visdomini.

Portrait of a Musician
c. 1518-19; oil on panel, 86x67;
Uffizi.

Portrait of Cosimo Pater Patriae,
1519, oil on panel, 86x65;
Uffizi.

Adoration of the Magi
1519-20; oil on panel, 85x190;
Palazzo Pitti.

Virgin and Child with the Young St John the Baptist,
c. 1523-25; oil on panel, 87x67;
Galleria Corsini.

Supper at Emmaus,
1525; oil on canvas, 230x173;
Uffizi.

Virgin and Child with the Young St John the Baptist,
1528-29; oil on panel, 89x73;
Uffizi.

Martyrdom of the Ten Thousand,
1529-30; oil on panel, 64x43;
Palazzo Pitti.

Venus and Cupid,
c. 1533; oil on panel, 128x197;
Gallerie dell'Accademia.

GALLUZZO (ITALY)
Christ Before Pilate,
1523; fresco, 300x290;
Pinacoteca della Certosa.

Deposition,
1523; fresco, 300x290;
Pinacoteca della Certosa.

HANOVER (GERMANY)
Penitent St Jerome
c. 1527-28; oil on panel, 105x80;
Niedersächsisches Landesmuseum.

LONDON (GREAT BRITAIN)
Joseph in Egypt,
1517-18; oil on canvas, 44x49;
National Gallery.

LUCCA (ITALY)
Portrait of a Youth,
c. 1525; oil on panel, 85x61;
Pinacoteca di Palazzo Manzi.

MALIBU (UNITED STATES)
**Portrait of Cosimo I
dressed as a Halberdier,**
c. 1527-30; oil on canvas, 52x40;
John Paul Getty Museum.

MUNICH (GERMANY)
The Virgin of the Book,
c. 1545; oil on panel, 120x102;
Alte Pinakothek.

PARIS (FRANCE)
Portrait of a Gem Cutter,
c. 1518; oil on panel, 69x50; Louvre.

**The Virgin and Child with
St Anne between St Peter,
St Sebastian, the Good Thief,
and St Benedict
(the St Anne Altarpiece),**
1529; oil on panel, 176x228;
Louvre.

PHILADELPHIA (UNITED STATES)
Portrait of Alessandro de' Medici,
1534; oil on panel, 97x79;
Philadelphia Museum of Art.

POGGIO A CAIANO (ITALY)
Vertumnus and Pomona,
1519-21; fresco, 461x990;
Medici villa.

PONTORME (ITALY)
St John the Evangelist,
1519-20; oil on panel, 173x59;
San Michele.

St Michael the Archangel,
1519-20; oil on panel, 173x59;
San Michele.

ST PETERSBURG (RUSSIA)
**The Holy Family
with the Young St John the Baptist,**
c. 1522-24; oil on canvas, 120x98.5;
Hermitage.

SANSEPOLCRO (ITALY)
St Quentin,
c. 1519; oil on panel, 163x103;
Pinacoteca Comunale.

BIBLIOGRAPHY

For further knowledge of the periods which characterized Pontormo's artistic development, the general catalogues of his work should be consulted.

1568 G. Vasari, *Lives of the Painters, Sculptors, and Architects* [complete English translation 1912, New York 1996]

1896 B. Berenson, *The Florentine Painters of the Renaissance*, New York and London

1916 F.M. Clapp, *Jacopo Carucci da Pontormo, his Life and Work*, New Haven

1921 C. Gamba, *Il Pontormo*, Florence

1947 E. Toesca, *Il Pontormo*, Rome

1955 *Mostra del Pontormo e del primo Manierismo fiorentino*, exh. cat., Florence

1956 L. Berti, *Pontormo e il primo Manierismo fiorentino*, exh. cat., Florence

E. Cecchi, *Jacopo da Pontormo. Diario*, Florence

1962 F. Zeri, *Eccentrici Fiorentini*, in *Bollettino d'arte*, XLVII, I, pp. 227-236, II, pp. 318-326

1964 L. Berti, *Pontormo*, Florence

1965 L. Berti, *Pontormo; disegni*, Florence

1973 L. Berti, *L'opera completa del Pontormo*, Milan

1976 F. Zeri, *Italian Paintings in the Walters Art Gallery*, Baltimore

1981 J. Cox-Rearick, *The Drawings of Pontormo: a Catalogue Raisonné with Notes on the Paintings*, New York, 2 vols.

1984 M. Apa, *Pontormo: La Visitazione a Carmignano*, Albano Laziale

D. Trento, *Pontormo: il diario alla prova della filologia*, Bologna

J. Pontormo, *Diario fatto nel tempo che dipingeva nel coro di San Lorenzo* (1554-1556), Milan

A. Hauser, *Il Manierismo*, Turin

1993 L. Berti, *Pontormo e il suo tempo*, Florence

S.S. Nigro, *Pontormo*, New York, Harry N. Abrams, Inc.

1994 P. Costamagna, *Pontormo*, Milan

A. Forlani Tempesti, A. Giovannetti, *Pontormo*, Florence

S.S. Nigro, *Pontormo*, Milan

C. Falciani, L. Gnocchi, *La maniera moderna in Toscana. Pontormo e Rosso*, Venice

Il Pontormo. Le opere di Empoli, Poggio a Caiano, Carmignano, Venice

1995 A. Conti, *Pontormo*, Como

1996 P. Costamagna, *Pontormo*, in *Art Dossier*, no. 110, Florence

ONE HUNDRED PAINTINGS:

every one a masterpiece

Also available:

*Raphael, Dali, Manet, Rubens,
Leonardo, Rembrandt, Van Gogh,
Kandinsky, Renoir, Chagall*

Vermeer
The Astronomer

Titian
Sacred and Profane Love

Klimt
Judith I

Matisse
La Danse

Munch
The Scream

Watteau
The Embarkment for Cythera

Botticelli
Allegory of Spring

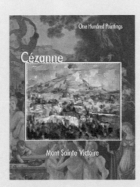

Cézanne
Mont Sainte Victoire

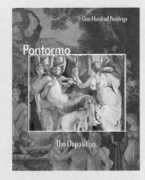

Pontormo
The Deposition

Toulouse-Lautrec
At the Moulin Rouge

Coming next in the series:

*Magritte, Modigliani, Schiele,
Poussin, Fussli, Bocklin, Degas,
Bosch, Arcimboldi, Redon*